The

Digital Imaging A–Z

Adrian Davies

focal press

Focal Press
An imprint of Butterworth-Heinemann
Linacre House, Jordan Hill, Oxford OX2 8DP
225 Wildwood Avenue, Woburn, MA 01801-2041
A division of Reed Educational and Professional Publishing Ltd

A member of the Reed Elsevier plc group

OXFORD AUCKLAND BOSTON
JOHANNESBURG MELBOURNE NEW DELHI

First published 1998
Reprinted 1998, 2000

British Library Cataloguing in Publication Data
A catalogue record for this book is available from the British Library

Library of Congress Cataloguing in Publication Data
A catalogue record for this book is available from the Library of
Congress

ISBN 0 240 51500 5

Printed in Great Britain by MPG Books Ltd, Bodmin, Cornwall

Introduction

The technologies involved in Digital Imaging cross many subject boundaries – computing, photography, publishing, printing, science, telecommunications and graphics to name but a few. Each of these technologies has it's own language, or jargon, often incomprehensible to people outside that particular industry.

This book is an attempt to bring together in one place those terms relevant to users of digital imaging, whether they be graphic designers, photographers or scientists, but does not pretend to be a comprehensive glossary for each of the areas mentioned.

The technologies associated with imaging are evolving rapidly, and systems come and go almost on a weekly basis. It is hoped that this book will be updated at regular intervals, and expanded with new terms as they come along.

The author would welcome comments from readers as to missing or new terms. He can be contacted via the publisher, or by e-mail at: adavies@nescot.ac.uk.

Aa

Accelerator card
An extra circuit board, or 'card' which fits inside the computer, designed specifically to speed up certain types of operation, or certain programs, such as **Adobe Photoshop**™. These cards may contain **digital signal processors (DSPs)** which help speed up mathematically intensive calculations or operations. Accelerators can speed up many operations by as much as 23 times.

Access time
In computing, the amount of time taken to retrieve information from a peripheral device such as a disk drive. Usually quoted in milliseconds (ms).

Acquire module
See **Plug-in**

Acrobat™
See **Adobe Acrobat**

Active matrix LCD
In this type of **LCD** display, each liquid crystal cell has its own transistor, providing a stronger charge, leading to better colour fidelity. They are generally more expensive than **passive matrix displays**.

ADB (Apple desktop bus)
The **bus** used by **Apple**™ computers for connecting the **mouse** and other input devices to the keyboard.

ADC (analogue to digital converter)
Circuitry designed to convert **analogue** signals into **digital** data. This can be fitted inside a computer to convert analogue video data into digital form. There are two basic types, either a **frame grabber**, capable of isolating single video frames, or **video grabbers**, for digitizing video sequences. **CCD** sensors provide analogue data which can be digitized through an ADC.

Additive primary colours
The three primary colours of light are red, green and blue. When mixed in varying proportions, all other colours can be synthesized. When mixed in equal proportions, 'white light' is the result.

Address
The location of a **pixel** within a **bitmap**.

Addressability
This is a measure of the spatial **resolution** of **film recorders**, and is the maximum number of pixels that can be recorded across the widest dimension of the film output format. Film recorders depart from convention by expressing their resolution in **K** rather than dots per inch. K refers to the number 1024 (kilo ...) i.e. 2^{10}, typical values being 2K, 4K and 8K. For example, a 2K film recorder will expose 2048 pixels in the 36mm width of a 24×36mm format on 35mm gauge film.

Adobe Acrobat™
A program for producing documents which can be viewed on any other computer (with Acrobat Reader software) regardless of the operating system, hardware or font configuration. It does this by creating **PDF** (portable document format) files.

Adobe Illustrator™
A commonly used **vector** based graphics program.

Adobe Pagemaker™
A commonly used program for **desktop publishing**.

Adobe Photoshop™
A pixel-based image editing program which has become an industry 'standard'.

Adobe Premiere™
A video-editing program for desk top computers.

Adobe Type Manager™
A program for improving the appearance of certain fonts on screen.

ADPCM (adaptive differential pulse code modulation)
An audio compression scheme for **CD-I** and **CD ROM XA** formats, either to increase the recording time length of audio, or to combine it with other data on the disc.

Advanced photo system
See **APS**

AIFF (audio interchange file format)
A file format for storing digital audio data.

Algorithm
A set of explicit rules, which, when applied to a problem, will give a solution. The rules can be applied without judgment, and thus can be programmed into a computer to carry out certain functions.

Aliasing
Refers to displays of bitmapped images, where both curved lines and diagonal straight lines appear to be jagged due to the way they are composed of square pixels (sometimes referred to as **staircasing** or **jaggies**).
See **Anti-aliasing**

(a) (b) (c)

Figure 1 (a), (b) and (c). The effects of aliasing on text: (a) shows aliased text, (b) shows 'anti-aliased' text, (c) shows text produced by a vector-based program.

Alpha channel
An 8-bit greyscale representation of an image often used either for storing any masking, or additional colour information about an image.

Alphanumeric
Data consisting of letters and numbers, but not usually punctuation marks or other symbols.

Amplitude
The strength of a **signal**, determining the brightness or loudness. It is measured in **decibels (dB)**.

Analogue (also spelt **analog**)
A signal that represents sound or vision by electrical analogy, e.g., variations in a DC voltage producing corresponding variations in luminance, or vice versa.

Similarly, a silver photographic negative is an analogue representation of the subject.

Animated GIF
See **GIF 89a**

Anonymous FTP
See **FTP**

ANSI (American National Standards Institute)
The ANSI defined an 8 bit character set which Microsoft **Windows**™ uses to represent **alphanumeric** characters and symbols.

Anti-aliasing
A method of reducing the effect of **aliasing** by averaging the densities of **pixels** at the edges of items such as text, thereby softening their appearance.

Anti-blooming
Circuitry built into modern **CCD**s designed to automatically drain excess charge caused by over-exposure of a CCD element.

Apple™
The manufacturer of the Macintosh and PowerPC computers, based on the Motorola 68000 series and **PowerPC** series of microprocessors respectively. The Macintosh was the first personal computer in common use to use a **Graphical User Interface (GUI)** rather than being text driven.

Application
Software in the form of a program such as **Adobe Photoshop**™.

5

Approval™ system

A digital colour proofing system from Kodak using a **thermal dye sublimation** printing process which uses the same dot structure to print the four (**CMYK**) dye colours onto the page. The dye ribbons in the printer are calibrated to the output inks. The system has the great advantage of being able to print the image onto the same paper stock as the final printed page.

APR (automatic picture replacement [Scitex™])

The process of substituting a high resolution scan at the pre-press stage, after the document has been laid out using **FPO** low resolution scans.

APS (advanced photo system)

A photographic format using 24 mm wide, cartridge loaded, non-sprocketed film. The system allows for three formats on the same roll of film:

- C (Classic) format: 3:2 aspect ratio
- H (**HDTV**) format 16:9 aspect ratio
- P (Panoramic) format: 3:1 aspect ratio

A basic idea of the system is to transfer photographic data such as date, exposure, use of flash or daylight, etc., to the photofinishing equipment by means of digital data recorded onto a transparent magnetic layer coated onto the back surface of the film base, and **information exchange** (**IX**) circuitry. The system is thus a **hybrid** system using both analogue photographic and digital technologies.

Area array CCD
See **CCD**

Area processes
Image processing routines performed on groups or blocks of pixels rather than on single ones. Such processes include **filters** for the enhancement of edges, sharpening and blurring of images.

Artefact (also spelt artifact)
Extraneous spurious digital information in an image resulting from limitations in the device used to create the image. Examples include **noise**, **aliasing**, **blooming**, and **colour fringing**.

ASCII (American standard code for information interchange)
A standard set of codes adopted by most computer operating systems for assigning individual code numbers to letters, numbers and commonly used symbols. Files saved as ASCII files are often called 'text only' files. There are 128 standard ASCII codes, each of which can be represented by a 7 digit binary number in the range 0000000 to 1111111.

Aspect ratio
The relationship between the width and height of a recorded or displayed image. For television it is currently 4:3.

Attachment
Any digital file sent with or attached to an **E-mail** message.

Automatic picture replacement
See **APR**

Bb

Background printing
The facility of a computer to print a document 'in the background' whilst using the computer for another operation in the 'foreground'.
See also **Buffer**

Background processing
The facility of a computer to process a document 'in the background' whilst running another operation in the 'foreground'.
See also **Buffer**

Back-up
A duplicate copy of digital data, made to prevent loss of the data through disc or system failure.

Banding
Where a continuous varying gradation of tone that is monochrome or coloured is represented digitally by too few grey levels or colours, then visible tonal 'bands' are seen. The effect is sometimes known as **contouring** or **posterization.**

Bandwidth
The difference between the highest and lowest values of a signal, expressed as a range of frequencies. The greater the bandwidth of a transmitted signal, the more data it can carry. Bandwidth is expressed in cycles per second, or Hertz (Hz).

Base resolution
A term used in **PhotoCD** systems where the standard, or 'base' resolution is 512×768 pixels – the resolution of consumer **NTSC** based televisions. Other components of the **PhotoCD Image Pac** are fractions or multiples of the base value, i.e. Base/16, Base/4, Base, 4Base, 16Base, 64Base.

Base/4
A PhotoCD image having one quarter the number of pixels of the base resolution image.

Base/16
A PhotoCD image having one sixteenth the number of pixels of the base resolution image.

4 Base
A PhotoCD image having four times the number of pixels of the base resolution image. This image would be suitable for display on an **HDTV** system and is sometimes called 'HDTV resolution'.

16 Base
A PhotoCD image having sixteen times the number of pixels of the base resolution image.

64 Base
A PhotoCD image having sixty-four times the number of pixels of the base resolution image (found only in the **Pro-PhotoCD** format).

Batch processing
Programming a computer to process several images or other files automatically, as time becomes available.

9

Baud rate

A measurement of the speed at which information is transmitted by a **modem** over a telephone line. Baud rates are in terms of bits per second (bps). Typical speeds are 1200, 2400 and 9600 baud and higher, now up to 36 600 baud. Strictly speaking, at speeds over 1200 bps, the terms baud and bits per second are not completely interchangeable. A 1200 bps modem actually runs at 300 baud, but it moves 4 bits per baud (4×300 = 1200 bps).

Bernoulli drive

One of the first types of removable disc storage systems, now largely obsolescent. It made use of a concept in physics, the Bernoulli Principle, which explains how an aerofoil provides the lift for an aeroplane. When the flexible recording media in the disc spins at high speed, the air pressure created forces the medium to rise up towards the read/write head. There is no physical contact between the head and disc, there being a gap of about 0.00025 mm between them. This system has the advantage that in the case of a power failure or mechanical knock, the disc loses some lift and falls away from the head, thus greatly reducing the risk of physical damage to the disc.

Beta version

A pre-release version of software which is sent out to accredited testers for the purpose of fault or **bug** finding.

Bezier curve

In 'object-oriented' drawing programs, a bezier curve is a mathematically defined curve between two points ('bezier points'). The shape of the curve can be altered by dragging 'handles' on the points. In **Adobe**

Photoshop™, bezier curves are used to define the **path** selection **tool**.

Bicubic
A method of **interpolation** whereby, in order to increase image resolution, the value of the new pixel is determined by averaging from all those surrounding it. It is the most accurate form of interpolation, but is the most time-consuming.

Bilevel
Images composed only of black and white tones.
See **Binary**

Bilinear
A method of **interpolation** whereby in order to increase image resolution, the value of the new pixel is determined by a weighted average of four pixels surrounding the pixel of interest.

Binary
A numerical coding system using only two digits, 0 and 1. Two binary digits, or bits, can give four possible combinations:

 00, 01, 10, 11

Three bits can give 8 (2^3) possible combinations:

 000, 001, 010, 011, 100, 101, 110, 111

A binary 'image' consists of just black and white tones.

Bit
Short for 'binary digit' – a single number having the value either zero or one, which may represent the states of 'on' or 'off'. Eight bits make up one **byte**.

Bit depth
See **Bits per pixel**

Bitmap
1 A **binary** representation of an image, in which each
 bit is mapped to a point (**pixel**) on the output device,
 where the point will either be on (black) or off (white)
 or vice versa.
2 An image formed by a rectangular grid of pixels, each
 one of which is assigned an **address** as x,y co-
 ordinates, and a value, either **grey scale**, or colour.

Bitmapped
An image converted to a bitmap.

Bits per pixel
The number of bits used to represent the colour value
of each pixel in a digitized image. 1 bit per pixel displays
2 colours, 2 bits gives 4 colours, 3 bits gives 8 colours,
etc. In general, n bits allows 2^n colours. Theoretically, a
24 bit (2^{24}) display can show some 16.7 million colours.

Bits per second (bps)
See **Baud rate**

Bitstream
A continuous sequence of bits.

Black point
The point on an image **histogram** which defines the
darkest area of an image.

Blooming
A problem with previous generations of **CCD** based
sensors that caused pixel level distortions when the

electrical charge created exceeded the pixel's storage capacity, and spilled into adjacent pixels. It is caused by overexposure of the image, and is particularly noticeable as halos or streaks around specular highlights. New CCD designs incorporate **anti-blooming** circuitry to drain away any excess charge.

BMP
Windows Bitmap™ or BMP file format is the native format for Microsoft Paint™, a paint program included with Microsoft **Windows™**. It is supported by a number of applications for Windows and OS/2. BMP images can be saved in up to 24 bit files, and be used in conjunction with **run length encoding (RLE)** which is a **lossless compression** system.

Brightness range
This term refers either to the range of brightness (luminance) values within a subject being imaged, or to the range of brightness values capable of being captured by an imaging system.
See also **Dynamic range**

Browser
Software that acts as a translator for digital data, and turns it into readable **Internet** pages. Examples are NetScape™, Mosaic™, and Microsoft Internet Explorer™.

Bubble jet printer
See **Ink-jet printer**

Buffer
An area of memory in a computer or peripheral device such as a printer, either as **RAM**, a separate **cache**, or **hard disc** sector set aside to undertake a specific function.

13

The **printer buffer**, for example, will store the information to be printed, thus freeing the **CPU** for other tasks.

Bug

A fault, or logic error, in a computer program which may cause either the program to fail, or the computer system to 'crash', or cause some feature not to work correctly. Before new programs are released onto the market, testers are supplied with **beta versions** to try and find any bugs. Due to the complexity of modern computer programs it is almost impossible for software writers to test all possible combinations that users might conceivably use.

Build

The term used by the image processing program **Live Picture**™ for the process of computing the pixels for outputting to a printing device from a **FITS** file.

Bus

A conducting pathway composed of thin metallic wires along which data travels as electrical signals to various parts of the computer. A typical computer will contain several buses, and different types of bus.

Byte

The standard unit of binary data storage in computer memory or disc files. A byte containing 8 bits can have any value between zero and 255.

> 1 Kilobyte (Kb) = 1024 bytes
> 1 Megabyte (Mb) = 1024 Kb (1 048 576 bytes)
> 1 Gigabyte (Gb) = 1024 Mb (1 048 576 Kb)

(Strictly, the term 'kilo' refers to 1000, but is here used for 1024, etc., because of the binary system used.)

Cc

Cache
High speed memory chips which store frequently used instructions. This is much faster than using conventional **RAM**.

CAD (computer aided design)
A term used to describe any design produced with the aid of a computer. It is more usually associated with such things as complex architects' plans, or drawings of manufactured components.

Card
See **Accelerator card**

Cast
An unwanted, overall predominance of one colour in an image.

Cathode ray tube (CRT)
See **CRT**

CCD (charge coupled device)
A solid state image pick-up device or **photosensor** composed of a rectangular matrix (**area array**), or single row (**linear array**) of light sensitive **picture elements** (or **pixels**, or **photosites**). Light falling on to these elements produces an electrical charge proportional to the amount of light received. The output voltage is in analogue form, and must be converted to digital form

by means of an **ADC** before it can be output to a computer.

Colour information in the optical image can be recorded by three alternative methods:

1. The image may be exposed three times, successively through red, green and blue filters, with a full colour image being re-constructed on a computer monitor.
2. The image may be recorded onto three separate CCD sensors by means of a beamsplitter, the light passing through the lens being split into its component red, green and blue values.
3. Each individual picture element can be coated with a transparent filter, in a particular pattern known as a **colour filter array (CFA)**. Various patterns are used, but the general rule is to divide the sensor into clusters of four sensor sites, one each for red and blue and two for green. The extra green is to match the sensitivity of the CCD as far as possible to the human visual system, which is most sensitive to green light.

G	B	G	B	G	B	G	B
R	G	R	G	R	G	R	G
G	B	G	B	G	B	G	B
R	G	R	G	R	G	R	G
G	B	G	B	G	B	G	B
R	G	R	G	R	G	R	G

Figure 2 Colour filter array. The pattern of colour filters used in many CCD sensors in digital cameras.

Area array CCDs may take the place of a frame of photographic film, and can be exposed by a single exposure with conventional lighting such as flash or daylight. Their resolution is usually quoted in the number of pixels present in the array. For example, 1012×1524 pixels = 1 542 288 pixels, yielding a 4.5 Mb file.

Area arrays are given an equivalent **ISO** rating. This value can be increased by amplifying the output signal. Most modern area array digital cameras have effective ISO ratings of 100 ISO, which can be increased to 200, 400 and 800 ISO. Increasing the ISO speed may cause an increase in **noise**.

The size of the CCD may be smaller than the film which it is replacing. This will affect the effective **focal length** of the lens being used by showing an apparent increase.

Linear array CCDs are used in **scanners**, and in 'scan backs' which fit onto the back of medium and large format film cameras in place of the film holder. They scan the image projected by the lens during exposure. This can take several minutes, limiting the use of such devices to still life subjects lit with continuous light sources such as daylight or **HMI lighting**. They can achieve higher resolution than area arrays. The resolution can be altered by increasing or decreasing the scan rate.

Linear array CCDs may either be one row of elements, which, when recording colour, scans the image three times, once each for the red, green and blue components of the image, or use three parallel rows of sensors separately filtered for each colour. This is known as a **trilinear array** CCD. The resolution of a linear array is quoted as pixels per inch, or dots per inch.

CCDs are inherently additionally sensitive to both

17

ultraviolet and **infrared** radiation as well as visible light. Most, at the time of manufacture, have an ultraviolet absorbing filter cemented over the surface of the CCD, to minimize the amount of ultraviolet recorded, though for scientific uses, CCDs can be purchased without this filter. Similarly, many cameras are supplied with infrared absorbing filters, to cut down the response to infrared in the light source, and help achieve a neutral colour balance.

CCD element pitch
The distance between the centres of two adjacent picture elements in a CCD. Values range from 7–25μm.

CD (compact disc)
A 120 mm diameter, 1.2 mm thick circular plastic disc, carrying a layer of highly reflective aluminium sandwiched between a layer of clear polycarbonate plastic and a lacquer coating, to prevent scratching, as well as oxidation of the aluminium. The surface of the reflective layer is known as the **land**, and data is recorded by stamping minute indentations into it, called **pits**. The data is recorded along an extremely thin (approximately 2 μm thick) spiral track (approximately 1/100th the thickness of a human hair) which, if straightened, would be about 4.83 km long. This track spirals from the centre of the disc outwards, and is divided into sectors, each of which is the same physical length. The motor which spins the disc employs a technique known as **constant linear velocity**, whereby the disc drive motor constantly varies the speed of spin so that as the detector moves towards the centre of the disc, the rate of spin slows down. To read the data, a laser beam is focused onto the aluminium layer through the transparent bottom surface of the disc. As light is reflected off the surface, variations in the reflected light are

interpreted via a detector as 'zeros' and 'ones', i.e. binary data which is input to a computer or microprocessor. A standard CD can hold 650 Mb of data. There are many different formats available, according to the type of data stored. These formats are defined by a set of standards known as the **Colour Book** standards.

CD-DA (compact disc digital audio)
Compact disc format used for sound data only, and capable of holding up to approximately 72 minutes of audio data. The standard is defined by the **Red Book**. The data is compressed, and encoded using **EDC/ECC** (error detection code and error correction code) to ensure the highest possible sound quality.

CD-E (compact disc erasable)
A compact disc that can be recorded and erased.

CD-I (compact disc interactive)
A version of the compact disc carrying text, audio and vision for interactive uses, defined by the **Green Book** standard.

CD-MO (compact disc magneto-optical)
This is a magneto-optical system employing rewritable storage media, but entirely separate from **CD-R**.
See **Orange Book standard**

CD-R
A recordable (once only) compact disc.
See **WORM**

CD-ROM (compact disc read only memory)
The term is often used to describe any compact disc, but is strictly defined by the **Yellow Book** standard to define additions to the **CD-DA** format so as to make them readable by computer.

CD ROM XA (extended architecture)
System using a similar standard to the CD ROM, but with some additional features for video and audio.

CD-WO (compact disc, write once)
A compact disc that is playable only. They are physically different from other CD ROMs, being housed in a special plastic cartridge. They are not compatible with standard CD ROM drives.

CEPS (colour electronic prepress systems)
An image manipulation and page layout system used in the graphic arts industry.

CFA (colour filter array)
A pattern or mosaic of colour filters overlaid on the photosensor elements of a **CCD**.

CGM (computer graphics metafile)
An **ANSI** file format for defining both raster and vector graphics in one file.

Channel
One of the major components of an RGB or CMYK image, e.g., red channel, or cyan channel.
See **Alpha channel**

Charge coupled device
See **CCD**

Chroma
The term used to describe saturation, intensity, or purity of a colour.
See **HSB**

20

Chrominance
The difference between two colours that are equal in brightness.

CID (charge injection device)
An imaging sensor similar to a **CCD**. Unlike the CCD, the CID does not move charges before readout. Instead, the charge on the CID remains stationary, and selective readouts are made from individual pixels. CIDs are particularly good at minimizing **smearing** and **blooming**.

CIE (Commission Internationale de l'Eclairage)
1 An international group set up to produce colour standards.
2 The name given to a **colour space** model.

CIE L*a*b*
A three dimensional mapping system used to define three colour attributes. L* represents the lightness of a colour, a* represents the red-green value, and b* represents the yellow–blue attribute.

Circle of confusion
The patch of light produced by a lens when it images a point source of light. When parts of an image are incorrectly focused, the overlapping circles of confusion cause a 'blurred' effect. Depending on the format, lenses designed for film cameras can generally resolve image detail between 20–100 μm, this figure being limited by the diameter of circles of confusion produced by residual lens aberrations.

When related to imaging with **CCD** sensors, then the circle of confusion produced by a lens need be no larger in diameter than the **CCD element pitch**. Modern

CCDs have element pitches ranging between 7–25 μm, though some **linear array CCDs** employing a sub-pixel shift system can have an equivalent value of about 3 μm. The lens used then must be good enough to produce the high resolution results of which the CCD sensor array is capable.

CISC (complex instruction set computer)
A type of computer architecture which sends instructions through different units of the computer one at a time. It is the system used by Motorola 68000™ series of microprocessors as used in **Apple Macintosh™** computers. It is rapidly being replaced by chips using **RISC** processors, such as the **PowerPC™**.

Clipboard
A designated part of the computer **RAM** which holds the last item **copied** or **cut** from a file. An item held in the clipboard can be **pasted** into other files.

Clipping
Loss of shadow or highlight detail due to the conversion of grey tones lighter than a certain value to white, or darker than a certain value to black.

Clipping path
A capability of **PostScript™** to allow an **EPS** file to contain an irregular border that defines it's edges. If the path has been defined, then points outside it will be transparent if it is imported into another application.

Clock speed
The effective rate at which the central processing unit (**CPU**) in a computer communicates with the various elements within it. The processor runs at a

fixed clock-speed, regulated by the pulses of a quartz or other crystal. The speed is rated in megahertz (MHz) – one megahertz representing one million instructions per second.

Cloning
The selection and duplication of groups of adjacent pixels within an image. For example, an area of skin tone can be 'cloned' from another area to hide a skin blemish. The cloning **tool** in most imaging programs can be varied to select different sized areas of pixels to be cloned, and the manner in which they are cloned.

CLUT (colour look up table)
See **LUT**

CMYK (cyan, magenta, yellow and black)
The three colours and black used by printers to produce printed colour illustrations using inks or dyes.

Colour Book standards
A set of standards defining the physical format of data recorded onto a variety of **CD ROMs**.

E.g. **Red Book**: defines the standards for audio CDs.

Other book standards include **Yellow Book, Green Book, Orange Book**, and **White Book**.

The Book standards do not address the issue of logical file format for CD ROMs. This is covered by the **High Sierra Standard**.

Colour difference signals
The two signals (CC) in a **YCC** format which carry the colour information:

red minus luminance
blue minus luminance
green is computed from the remainder.

Colour filter array (CFA)
See **CCD**

Colour fringing
An artefact in **CCD**s where colour filtering conflicts with information in the subject.

Colour management
The system used to try and achieve correspondence and uniformity between the original subject, the image displayed on the monitor screen, and the colour of the final printed output.

Colour separation
The process of separating an image into its component primary colours usually for the purpose of printing in complementary colours. Four colour litho printing requires cyan, magenta yellow and black separations. The process can be carried out either at the time of scanning, or in image capture with some digital cameras, or with computer software.

Colour space
A three-dimensional space or mathematical model where three attributes of colour such as hue, saturation and brightness can be represented, e.g., **CIE** Colour Space, **Munsell colour system**.

Colour Studio™
See **RIFF**

Colour temperature
A term referring to the predominant colour of a
particular light source. It is measured in degrees Kelvin
(K). It is a measure of the relative amounts of red and
blue wavelengths in the light source – the redder the
light source, the lower the colour temperature. Common
examples are:

'photographic' tungsten	–	3200 K
electronic flash	–	5500 K
HMI lighting	–	5600 K
'average daylight'	–	5500 K

(Daylight is extremely variable, ranging from the red/
orange light of sunrise/sunset, to dull overcast
conditions which may have a colour temperature in
excess of 10 000 K.)

Colour films are balanced for particular colour
temperatures, usually daylight (5500 K) or tungsten
(3200 K). **Video** and **CCD** devices can be '**white
balanced**'. Colour temperature meters are available,
which measure the relative amounts of red and blue in
a light source.

An alternative way of expressing colour temp-
erature is the **MIRED** (microreciprocal degree) which
represents one million divided by the Kelvin value of the
source. Daylight of 5500 K corresponds to 182 Mired.
Filters for modifying colour temperature are usually
quoted in Mired shift values.

Colour trapping
A printing term referring to the solution to slight
mis-registrations in the printing process. If
two colours are mis-registered, a white or coloured

line will appear around the object. **Trapping** is the process of adding extra colour to fill in the gap created. Programs such as **Adobe Photoshop™** have trapping capabilities.

Comb filter
An electronic filter that separates the **chrominance** and **luminance** information in a signal.

Composite signal
A television output signal that consists of the video signal (**luminance** and **chrominance**), burst signal, and sync signal (horizontal and vertical).

Compression
A digital process that allows data to be stored or transmitted using less than the normal number of bits. Compression can be **lossless**, **lossy** or **visually lossless**. There are several types, of which the **JPEG** standard of lossy compression is becoming widely accepted for still imaging. In general, compression should not be used where images may be required for scientific analysis, for although the data loss may not be visually apparent, from a scientific or legal point of view it may be essential.

Constant angular velocity
The motor which rotates magnetic discs spins at a constant rate – a point close to the centre of the disc rotates more slowly than a point at the edge of the disc. To counteract this feature, less data is stored in the outer tracks than in the inner tracks, which reduces the overall capacity of the disc.

Constant linear velocity
The motor which spins a compact disc employs a technique known as constant linear velocity, whereby the disc drive motor constantly varies the speed of spin so that as the detector moves towards the centre of the disc, the rate of spin slows down. This contrasts with magnetic discs, which spin at a **constant angular** velocity.

Constrain
To limit the proportions, angles or shape of an object when it is moved or changed on screen.

Contone (continuous tone)
An image exhibiting a full range of tone or colour, without obvious **contouring** or **posterization**. In the case of digital images, grey scale images should have a minimum of 256 tones (8 bit), whilst with colour images, each **channel** of colour information should be represented by 256 tones.

Contouring
See **Banding**

Contract proof
A colour proof of sufficiently high quality that printers will accept it as a guide to showing how the final printed result should appear.

Contrast
The relationship between the lightest and darkest parts of an image.

Convolution
The application of a mathematical process to an image or part of an image. An example is the application of a **kernel**, or **filter**.

Convolver™
A **plug-in** for **Adobe Photoshop™** which allows users to experiment with an infinite variety of filtration effects in real-time, before applying the final effect or combination of effects to the whole image.

Coprocessor
Separate digital processing units associated with the main processor, which undertake specific functions, such as mathematically intensive operations. Often referred to as **maths coprocessors,** or **floating-point unit** coprocessors (FPU).

Copy
To make a copy of a selected piece of text or image and store it temporarily in the **RAM** of the computer for later '**pasting**' into another file, or part of the same file.

CPU (central processing unit)
The 'brain' of a computer. The CPU controls the flow of data around the computer, using its **instruction set**, and the known locations of memory, registers and input and output devices. The performance of the computer is generally determined by the speed at which the CPU can process data, and how fast it can transfer information. A common measure is **MIPS** – millions of instructions per second. The speed

will also be dependent upon factors such as buses, interfaces, amount of memory, etc.

Crash
A condition where a computer fails to respond to instructions from the keyboard, or other input devices such as a mouse. It may have a number of causes, including conflict between various items of software or hardware. It usually requires the computer to be restarted. Any work not saved, and therefore stored only in RAM, will be lost. Also known as 'bomb', 'freeze' or 'hang'.

Cromalin™
A page proofing system produced by the Dupont Company which uses the same technique of generating the four printing separation images CMYK. However, the film separations have a laminate applied to the backing of each. The action of exposing the film to ultraviolet light hardens the exposed areas and leaves the unexposed areas with a sticky surface. After each exposure the laminate is passed through a processor unit containing finely powered pigment of the appropriate colour which adheres to the surface. After all four separated layers are assembled the surface is covered with a protective film and the composite layers hardened.

Crop marks
Lines and other symbols, printed around the edges of pages or images, to show where the final page or image should be trimmed.

Crosfield CT™ (continuous tone)
A file format allowing files to be exported directly into Crosfield work stations.

Cross platform
A file format that allows computer data to be transferred from one computer system to another, e.g., from an **IBM PC** to **Apple Macintosh™**. A common example is **TIFF**.

Crosstalk
See **Parallel port**

CRT (cathode ray tube)
The device which forms the basis of television and computer **monitor** displays. It consists of an evacuated glass tube with a phosphor screen at one end and electron guns at the other, in which a coil

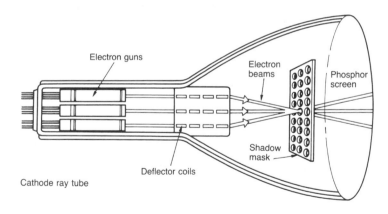

Figure 3 Cathode ray tube, showing electron beams generated by three electron guns. A shadow mask ensures that each beam strikes the correct phosphor.

of wire is heated to produce a stream of electrons.
The negatively charged electrons are accelerated and
focused to form a beam which strikes the rear of
the phosphor screen. This is coated with phosphors
which emit light when struck by the electrons. The
beam is deflected, either by magnets, or electrostatic
forces, to form a scanning, or **raster** pattern on the
screen. Typically, the beam moves from left to right,
and vertically, until one scan of the screen has been
completed. On reaching the bottom of the screen, the
beam 'flies back' to the top, but slightly underneath the
first line, to complete another scan. The two scans
(**fields**), are **interlaced** to produce a single **frame**. In
colour systems, three electron guns generate signals
for each of red, green and blue input data. Three
types of phosphor are coated onto the screen, (RGB),
either as narrow closely spaced stripes – the Trinitron™
system, or as patterns of dots arranged in groups
of three (**triads**). Immediately in front of the screen
inside the CRT is a grill of fine wires known as an
aperture mask or **shadow mask**, so designed that
the electron beams from the three guns strike the
appropriate colour phosphor.
See also **Monitor**

Cursor
Symbolic representation of a particular computer **tool**
(text, paintbrush, cloning tool, etc.) which can be
moved around the screen, usually by means of the
mouse. Clicking the mouse button will determine the
insertion point – the point on the screen where the
operation will commence. Different programs will
have their own cursors for their own specific range
of tools – **Adobe Photoshop™** has over 40 cursors
at present.

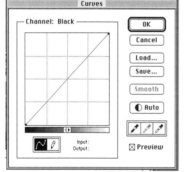
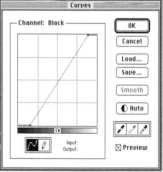

Figure 4(a) and (b) 'Curves': this complex control acts in a similar way to the characteristic curve of a film emulsion. (a) shows the default setting, (b) shows an increase in the angle of the curve, which would lead to an increase in image contrast.

Curve

A graphical representation of the contrast and colour of an image. Most image processing programs offer the capability of modifying the image using the

curves control. Sometimes referred to as the '**gamma curve**' (see Figure 4).

Cut

To remove or cut a selected piece of text or image from a file. The cut selection is stored temporarily in the computer memory, and may later be **pasted** into another file, or another part of the same file.
See **Clipboard**

Dd

DAC or D/AC (digital to analogue converter)
A circuit board for converting digital data into analogue data. One example is where digital video data is to be output to analogue video tape.

Dark current
Even when no light falls upon a **CCD** sensor, a small background charge, the dark current (**noise**), builds up in the pixels. When the level of charge induced by light is not significantly higher than the dark current i.e. the **signal to noise ratio** is low, then image quality may become unacceptable.

In practice, when a CCD is operated using an **open flash** technique, levels of unwanted noise may appear in the image. CCDs designed for scientific use, where long exposures may be required, may be electronically cooled by a 'Peltier element'.

DAT (digital audio tape)
These are tape drives which allow the storage of large amounts of information on small, relatively inexpensive tape cartridges. They work on a similar principle to video tape recorders except that the data recorded is **digital** rather than **analogue**. A recording drum, with two heads spins at high speed. Tape is moved past the heads at a slight angle to them so that data is written to the tape as narrow diagonal tracks rather than a continuous track along the length of the tape. This increases the usable area of the tape allowing more information to be

stored. The format of the data on the tape conforms to the **DDS** (digital data storage) standard.

As well as the raw data, indexing information is included to speed up retrieval of the data. Also, most drives have built-in hardware compression. This is much faster than software compression. Two types of tape are available, namely DDS and DDS–2. DDS tapes are 60 or 90 metres long, the 90 m storing approximately 2 Gb of uncompressed data. DDS–2 tapes are 120 m long and can store up to 4 Gb of uncompressed data, and have faster drive mechanisms. DDS–2 tapes cannot be used in DDS drives.

Several sizes are available, such as a single 4 mm wide tape capable of holding 2 Gb of data. One problem with all tape systems is that if the information required is in the middle of the tape, then the tape must be wound physically to that point. This makes them relatively slow for jumping backwards and forward between files, but excellent when recording large amounts of information in a sequential fashion. Whilst the tapes are very cheap and the system very reliable, the drive units themselves are quite expensive.

Database
A collection of digital data which can be arranged in various ways, and accessed randomly. Examples are names and addresses, which can be arranged alphabetically, and accessed by surname, town or postcode. Image databases are used for the digital storage and retrieval of images by picture libraries. The success of an image database is dependent on the way that the library or photographer catalogues the collection. Most use a system of keywords associated with an image. So an image of a badger, for example, might have the following attributes associated with it:

Common name	–	badger
Latin name	–	*Meles meles*
Typical habitat	–	woodland
Type of animal	–	mammal
Habits	–	e.g., nocturnal, omnivore, etc.

Each keyword can be used to search the data base. Thus, a researcher might ask to view pictures of woodland mammals, or nocturnal animals for example. A search can be made using 'either', 'and' and 'or' commands, so that a search can be made for 'mammal' *and* 'nocturnal' for example, or 'woodland' *or* 'nocturnal' *and* 'omnivore'. Such systems usually rely on low resolution **thumbnails** which can be viewed on screen, or transmitted to a researcher for selection purposes.

dB
See **Decibel**

DCS
1 **Desktop colour separation**
 An image file format consisting of four separate **CMYK PostScript™** files at full resolution plus a fifth EPSF master for placement in documents
2 **Digital camera system**
 The name for a range of Kodak's digital cameras, based on the **MegaPixel™** imager attached to conventional Nikon™ and Canon™ cameras.

DDS (digital data storage)
See **DAT**

Decibel
Literally, one tenth of a Bel. The logarithmic measure of relative intensity of power or voltage.

Default
Settings which a computer program uses unless deliberately altered by the user.

Density
An optical measure of the light absorbing properties of items such as filters, pigments and photographic images.

Densitometer
An instrument used to measure the opacity of film (transmission) or reflectivity of paper (reflection). Image processing programs incorporate the equivalent of a densitometer where the brightness and colour values, and address of individual pixels can be determined.

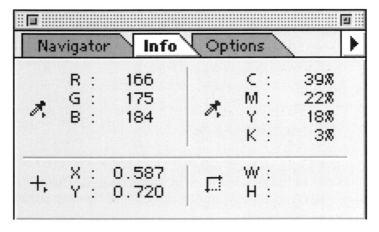

Figure 5 Image processing programs such as Adobe Photoshop have the equivalent of a photographic densitometer. This is the 'Show Info' dialog box in Photoshop 4.0, showing pixel density and colour, and X,Y address.

Density range

The difference between the optical densities of the lightest and darkest parts of an image.

De-screen

A filter, often built into scanner software, for removing or minimizing the effects of the half-tone **dot screen** of a printed image.

Desktop colour separation
See **DCS**

Desktop publishing (DTP)

The bringing together of various elements such as text, graphics and digital photographic images into an overall design concept, which can be output as one integrated package. Computer programs such as **Adobe Pagemaker™**, and **QuarkXpress™** are industry standard desktop publishing programs for desktop computers.

Despeckle

A filter within many image processing programs that eliminates randomness in an image. It tends to soften the appearance of an image.

Device independent colour

A **colour management** system which controls the input and output of colour independently of the computer system being used.

Dialog box

A box which appears on screen following a command from the user, allowing the user to control or execute instructions.

38

Dichroic filter
See **Interference filter**

Dichroic mirror
A type of **interference filter** which reflects a specific part of the spectrum, and transmits the rest. Found in scanners to split light precisely into the three components of red, green and blue.

Differencing
An operation whereby one image is subtracted, pixel by pixel, from another. The technique may be used in scientific and technical applications to show differences in scenes over a period of time.

Digital
A signal that represents changes as a series of individual values rather than the infinitely variable **analogue** signal.

Digital audio tape
See **DAT**

Digital camera
A camera that uses light sensitive **CCDs** rather than silver halide-based film to record images. They may either consist of conventional film cameras, where a CCD is placed in the film plane, replacing the film, or be purpose designed cameras. Two types of sensor are found, **area** or **matrix array CCDs**, or **linear array CCDs**.
 Area Array CCDs: Various models are available, ranging from **low end** cameras costing a few hundred pounds with CCDs containing perhaps 600 000 pixels, to **high end** cameras costing many thousands of pounds, with CCD chips containing up to 6 million pixels. Some

models are available as either monochrome or colour, or infrared sensitive cameras. In most, colour is recorded by having an integral mosaic filter pattern on the CCD chip, though a few have three CCD sensors, one each for each of red, green and blue.

Linear array CCDs: this type of camera is commonly known as a **scan back**, where a linear array CCD is made to scan, line by line, the image projected by the lens. They are generally expensive, and used for high end applications such as advertising.

Digital camera system
See **DCS**

Digital signal processor (DSP)
See **Accelerator card**

Digitize
To convert into digital form. Digitization is subdivided into the processes of **sampling** the **analogue** signal at a moment in time, **quantizing** the sample (allocating it a numerical value) and coding the number in **binary** form. A digital image is made up of a grid of points. There is no continuous variation of colour or brightness. Each point on the grid has a specific value. Digital images are recorded as data, not as a signal.

Digitizing tablet
A flat plate, usually A5 or A4 in size, where drawing and pointing operations are carried out with a **stylus** which looks and acts very much like a pen. Much finer control over drawing, or making selections is possible with the stylus, which is usually pressure sensitive. When painting in programs such as

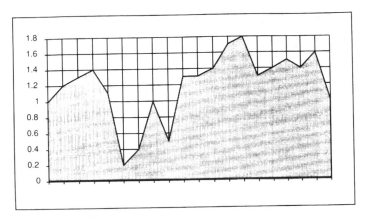

Analogue signal

Digital signal

Figure 6 Converting analogue information into digital data. The analogue sample records all information, but the digital records the same information in terms of discrete samples. The greater the number of samples, the closer the signal resembles its analogue counterpart.

Letraset's Painter™ or **Adobe Photoshop™** the more pressure that is applied to the stylus, the more 'paint' is applied. Unlike a mouse which can be raised, and moved to another part of the mouse mat without altering the position of the cursor on the screen, the positioning of the stylus on the tablet dictates the position of the cursor.

DIMM (dual in-line memory module)
A later version of the **SIMM**, and used to increase the **RAM** of a computer.

DIP
1 **Digital image processing**
 See **Image processing**
2 **Document image processing**
 The technologies associated with the scanning, enhancement and storage of documents, particularly those composed primarily of text, which are often scanned using **OCR** software.

Direct to plate
Direct exposure from digital data onto printing plates, without any intermediate film stages.

Direct to press
Direct transfer from digital data onto printing cylinders for a printing press, without the intermediate stages of film and printing plates.

Discrete sampling
The process of taking separate samples and quantizing them to produce a **digital** representation of an **analogue** image.

42

Dithering
A method for making digitized images appear smoother by using alternate colours in a pattern to produce a new perceived colour, e.g., displaying an alternate pattern of black and white pixels produces grey. It has also become widely used to refer to the process of converting greyscale data to bitmap data, and thus to a reduced grey tone content.

D_{max}
The maximum density that a print or other recording medium can achieve.

D_{min}
The minimum density that a print or other recording medium can achieve.

Document image processing
See **DIP**

Domain name
A unique alphabetic representation of the location of a particular computer within a network.

DOS (disc operating system)
The name of the **operating system** for PCs based upon Intel CPUs. More correctly it should be referred to as MS-DOS™ (Microsoft disc operating system).

Dot
The individual element of a **halftone**.

Dot gain
The increase in the size of a halftone dot when it is printed onto paper with ink. The effect is caused by the

ink spreading into the paper, and the pressure of the rollers used to apply the ink.

Dot matrix
A type of printer using an array of pins (usually 9 or 24) which impact onto a ribbon thus transferring ink onto the paper. The pattern of the dots forms the shape of the character. The more dots used, the better the quality. A 24 pin system is sometimes referred to as **near letter quality (NLQ)**. They are not usually used for printing digital images.

Dot pitch
The physical distance between the holes in a **shadow mask** on a computer monitor. Typical values are 0.2 to 0.3 mm. The closer the holes, the sharper the image.

Dot screen
See **Halftone contact screen**

Dots per inch (DPI)
A measure of the resolution of a scanner or printer.

Dotted quad
See **IP address**

Download
To obtain digital data such as images or programs from the Internet.

Downsampling
To reduce the resolution of an image.

DPI
See **Dots per inch**

Drag and drop
To 'drag' a file, using a mouse onto a program icon, and 'drop' it, where it will automatically open, or print.

DRAM (dynamic RAM)
The type of memory chips used in most desktop computers. They are called 'dynamic memory' because their contents are constantly changing, and they require an electronic signal called a refresh signal, to enable them to retain their contents. The DRAM chips are arranged in groups on circuit boards called **single in-line memory modules (SIMMS)**.

Driver
Software which controls an input or output device such as a scanner or printer.
See **Plug-in**

Drum scanner
A **high end scanning** device for originals in the form of transparencies, negatives or prints. Most drum scanners use either xenon or tungsten halogen light sources, which are focused by a series of condenser lenses onto the original to be scanned. Transparency material, reflective prints and artwork are taped to the outside of a perspex drum, which rotates at 1000 revolutions per minute. Transparencies are lit from the inside of the drum, and reflective materials from the outside. As the drum rotates, a unit containing three **photo-multiplier tubes (PMT)** travels across the surface of the drum, thus 'scanning' the original. Three

PMT tubes are usually used, one for each of the three primary colours of red, green and blue. A fourth is sometimes used to provide image sharpening information, although this is usually accomplished now with software. Drum scanners usually have a higher **dynamic range** than flatbed or film scanners, and are capable of higher resolutions, though they tend to be more expensive.

DSP
See **Digital signal processor**

DSU™ (digital storage unit)
The name given to the storage device used with the world's first digital camera, the Kodak DCS100. The storage unit contained a hard disc, a small LCD display screen for 'in the field' editing, and transmission facilities for sending images via telephone lines. It was aimed primarily for use by photojournalists.

DTP
See **Desktop publishing**

Duotone
A greyscale image printed with two inks. Programs such as **Adobe Photoshop™** also provide the option for tritone images (three inks) and quadtone images (four inks).

DXF
A graphic file format developed for **CAD (computer aided design)** systems.

Dye sublimation
A type of thermal printer giving prints of near photographic quality, whereby dyes are transferred onto

46

Maximum densities of various imaging systems:

1. D max limit of best PMT scanner
2. D max limit of best transparency
3. D max limit of Photo CD scanner
4. D max limit of good desktop scanner
5. D max limit of reflective print and printed page

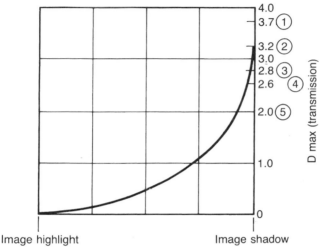

Image highlight Image shadow

Figure 7 Dynamic range of various imaging systems.

the paper (or film) in succession.
See also **Thermal dye sublimation printer**

Dynamic effects
Image processing procedures including *flipping, rotating, distorting* and *sizing* of images.

Dynamic range
A measurement of the range of light levels recorded by a **CCD**, **PMT**, or other imaging system.

Ee

ECS (electronic image capture system)
A camera that contains a CCD image sensor, and records images electronically.

EDC/ECC (error detection code and error correction code)
See **CD-DA**

Edge detection
A filtering technique or routine often used in scientifiċ image analysis (but also for creative purposes) where a continuous tone image is converted to a **binary** image with a white background, and where black outlines represent edges in the original image.

Edge enhancement
A filtering technique in image processing programs for increasing edge detail in images.

EGA (enhanced graphics adapter)
A standard that specifies 640×350 pixels with a capability of 16 colours from a total palette of 64 colours.

Electromagnetic spectrum
The range of electromagnetic radiations arranged in order of decreasing wavelength, from long wave radio to short wavelength X-ray and gamma rays. Some examples, of particular relevance to photography and digital imaging are:

Type of radiation:	Approximate wavelength (in nanometres – nm)
infrared radiation	700 – 900
visible light:	
red	650 – 700
orange	600 – 650
yellow	580 – 600
green	500 – 580
blue	450 – 500
violet	400 – 450
ultraviolet	10 – 400

Electron beam recording
A method of recording the signals carried by a modulated electron beam directly onto photographic material. The method requires a vacuum environment.

Electronic still photography
A term used generally to describe the first electronic images from analogue still video cameras.

Element pitch
See **CCD element pitch**

E-mail (electronic mail)
Messages, usually text only, sent from one person to another via computer networks. E-mail messages can be sent to groups of people and have other files attached to them.
See **Attachment**

Encryption
To place hidden (or visible) codes into documents. With

digital images, a digital **watermark** can be placed in an image to deter copying, or invisible codes can be **encrypted** into the image. **PhotoCD** offers the facility of watermarking. A recently introduced encryption system, is known as **FBI (fingerprinted binary information)** which changes the values of the least significant bits in a series of pixels, to encode a **fingerprint** – perhaps text. The changes are very small – perhaps less than 0.5 per cent, so that a 'fingerprinted' image will appear no different from the original. The program allows millions of possible ways of encrypting the fingerprint, and because the changes are distributed throughout the image, manipulation will not remove them all. In a typical image, more fingerprinting will be put into areas of high subject detail, whilst areas of less significance such as backgrounds will have less encoding.

Enhanced graphics adapter
See **EGA**

Enhancement
Improvements to the brightness, contrast or colour of an image.

EPI (elements per inch)
A measure of output device resolution. The number of exposing (sampling) elements in one inch.

EPS (encapsulated PostScript)
Refers to a standardized **file format** used widely in desk top publishing software. It is a file containing **PostScript™** commands, with additional data to enable it to be incorporated in other documents. The main data is 'encapsulated' by these additional commands.

Equalize
A **command** in image processing programs such as **Adobe Photoshop™** where the lightest value of an image is converted, or mapped, to white, and the darkest tone of the image is mapped to black. The remaining colours or tones are then distributed evenly between these two points.

Equivalent ISO ratings
The relative sensitivity of a **CCD** sensor, compared to the **ISO** rating of a film emulsion.

Error correction code (ECC)
See **CD-DA**

Error detection code (EDC)
See **CD-DA**

ESC (electronic still camera)
A camera that contains a **CCD** image sensor, and records images electronically.

Ethernet™
A common way of networking computers in a Local Area Network. Ethernet™ can handle about 10 million bits per second, and can be used by almost any computer system.

Eudora™
A commonly used program for sending and receiving **e-mail** messages.

Exabyte
A form of digital data storage using magnetic tape.

51

Exif (exchangeable image format)
A file format used in Fuji™ digital cameras.

Export module
A device to provide the facility to send files or data to other programs, or to an output device. Many printers are supplied with export modules – small pieces of software sometimes called **plug-ins** which allow the user to send the data directly to the printer. Also, **paths** created in programs such as **Adobe Photoshop™** can be exported to graphics programs such as Adobe Illustrator™.

Ff

Facsimile
The electronic transmission of printed material from one location to another using telephone lines.

FAQ (frequently asked questions)
Documents that list and answer common questions. Most newsgroups on the **Internet** have specific pages to deal with these, so as not to clog the system with simple questions.

FAX
See **Facsimile**

FBI (fingerprinted binary information)
See **encryption**

Feathering
The edges of selected areas of images can be softened, or 'feathered' to help blend them when combined with other images.

Field
One half of a video picture, composed either of the odd or even line scans which **interlace** to form a complete **frame**.

Field frequency
The frequency at which two **fields** are **interlaced** together to make a single **frame**. With **PAL** television

systems, the field frequency is 50 fields per second, with **NTSC**, 60 per second.

FIF (fractal image format)

A **file format** for images which uses the principles of **fractal** mathematics for **compressing** the data. Relatively huge savings can be made in the file size with relatively little loss of quality. The format is currently uncommon but may become increasingly important for storing large single images, or for video sequences. At present, fractal compression requires an extra board in the computer.

File formats

The overall format in which any digital data file is saved. Choosing the correct format for saving images is important to ensure that the files are compatible with various software packages. Some formats **compress** the data for storage. Examples of image file formats include **TIFF**, **EPS** and **PICT**. Most file formats consist of two parts, namely the *data*, and the *header*. The data represents the information created and saved, whilst the header records additional information relating to the properties of the file. On an IBM PC platform, header and data information are stored as a single file, whilst on an **Apple Macintosh™** platform, some of the information is stored separately, in an invisible area known as the '**resource fork**'.

File size

In general, the file size of an image is determined by the formula:

total no. of pixels×no. of bits per colour divided by 8 = total no. of bytes

for example:

an image has 1200 × 800 pixels = 960 000 pixels
960 000 × (24/8) = 2 880 000 bytes (2.8 Mb)

This figure will vary however, according to the **file format** used to save the image.

The size of the file when stored on a disc will depend on a number of factors such as the amount of information present (i.e. **resolution** of the image) file format (e.g., **TIFF**, **EPS**) and any **compression** routine used.

The following table gives the size of the *stored* file of a 4 Mb image saved in a number of file formats:

Photoshop™ 4.0:	2.1	Mb
TIFF with LZW compression:	1.8	Mb
JPEG: 'good' setting:	104.0	Kb
JPEG: 'excellent' setting:	47.0	Kb
JPEG: 'fair' setting:	1.1	Mb
EPS:	5.6	Mb

Fill
Where a selected part of an image is 'filled' with a colour or tone.

Film recorder
A device for outputting digital image data onto photographic film. There are basically two types, namely analogue and digital.

Analogue film recorders use a **cathode ray tube** onto which the image is projected. Three successive exposures are made by a film camera system, one for each of the three primary colours (**RGB**). This system can be regarded as the automated version of photographing a computer monitor in a darkroom using

a conventional camera system. System resolution is always dictated by the resolution of the CRT display. This type of recorder normally uses 35mm film, and is primarily aimed at the presentation market.

Digital film recorders use a **laser**, or light emitting diodes, (LED's) to 'draw' the image onto the surface of the film. The resolution can be increased by controlling the dot forming the image and the number of pixels it draws to form the image. The system is designed to recreate large format transparencies from retouched images on **high end** systems. The size of files needed to generate a film image is very large. A 5×4 inch colour transparency would typically require 60 Mb of data. It is also possible to produce colour negatives, which can then be printed onto photographic paper.

Film recorders depart from convention by expressing their resolution in **K** rather than dots per inch. K refers to the number 1024, meaning the **addressability** of the system. Typical values are 2K, 4K and 8K.

Film scanner

Film originals can be scanned either by using a **drum scanner**, or a **flatbed scanner** with a transparency adapter, or a purpose built film scanner. Film scanners typically scan only 35 mm or medium format film images. Two sensor systems are used, namely **linear array CCDs** and **area array CCDs**. With a linear array sensor, a single row of **picture elements** is moved across the surface of the film using a stepper motor. The physical resolution is dependent on the number of cells in the array and the accuracy of the motor. Resolution is increased by reducing the distance moved by the stepper motor between samples. The colour information is recorded either by a three pass system, once for each of red, green and blue information of each pixel, or in a

single pass using a filter coating on a **tri-linear CCD** array to record colour.

In the **area array CCD**, three consecutive images are captured using red, green and blue light. Although generally more expensive, this system produces much better results and is quicker than the linear sensor method. Physical resolution can be increased by linear movement of the sensor array by a half pixel distance and then combining two sets of the three colour images.

Film scanners generally are capable of high resolution. A scanner dedicated for 35 mm originals should have a resolution of at least 2000 dpi, which will yield a file size of approximately 18 Mb.

Filmstrip

A file format designed specifically for exporting lengths of digital film, such as **QuickTime**™ movies, from **Adobe Premiere**™ into **Adobe Photoshop**™. Individual frames can be edited, then exported back into Premiere™ for inclusion in its video editing program.

Filter

1 A software routine which modifies the character-istics of an image by changing the values of certain related or adjacent pixels. Examples are *sharpening*, *blurring* and *distortion* filters.

2 A transparent sheet of flat, usually coloured, material placed in a light path to selectively absorb certain wavelengths of light from the light path. Examples are *colour conversion filters*, for converting a particular colour film for a particular light source (e.g., for using daylight balanced colour film in tungsten lighting), *ultraviolet absorbing filters*, and *neutral density filters*, for absorbing light evenly from all parts of the visible spectrum, in order to reduce exposure times.

Fingerprint
See **Encryption**

Firmware
Software that is stored permanently in **ROM** (read only memory) so that it cannot be altered.

FITS file
The screen representation of a composite image created in **Live Picture™**.

FITS (functional interpolating transformation system)
The technology used by **Live Picture™** which provides resolution independcnt images.

FlashPix
An image **file format** developed jointly by Kodak™, Live Picture™, Microsoft™ and Hewlett Packard™. It is a multi-resolution image file format in which the image is stored as a series of independent arrays, each representing the image at a different spatial resolution. For example, if the original image is 1280×960 pixels, then the format would have versions measuring 640×480, 320×240, 160×120, 80×60 and 40×30. This allows the image to be displayed on different output devices at different resolutions with minimal resizing of the image. Each version is divided into tiles, 64 pixels square. As the operator zooms in and out of the image, the software selects the appropriate resolution for the screen display. Any changes made to the image are recorded in a script, which is a part of the file. Any information here can be applied to any of the resolutions of image.

A FlashPix file generally requires 33 per cent more disc space than a **TIFF** file (uncompressed) because of

the extra resolutions contained within it. However, it requires about 20 per cent less RAM for viewing than a comparable TIFF file and takes less time to modify it and store the revision.

Flatbed scanner

A **scanner** for both reflective and transparency materials. The original to be scanned is placed on a glass plate. With reflective materials, light from a fluorescent or halogen light source is shone onto the surface and reflected from it onto a **linear array CCD** across the width of the scanner unit. With transparency materials, a light from above is directed through the transparency onto the CCD array. This unit is mounted on a moving carriage which transports the light and recorder in small steps between each scan. The scanner light reflects off the original as the light moves across it and the recorder detects variations in light reflected from the grey tones or colours in the original. The resolution of typical flatbed scanners ranges from 100 dpi to 600 dpi, which may be **interpolated** to give 1200 dpi in some cases.

Transparency adaptors for flatbed scanners are available which provide an adjustable optic path to scan film originals rather than use reflected light. However the average sampling rate of a flatbed scanner would be in the range of 75–300 samples per inch and although this can give excellent results from a 10×8 inch piece of film, the result from 35 mm film would be poor. The best results from smaller film formats are obtained from purpose built **film scanners**.

Flicker

The visual perception of a rapid variation in brightness

when viewing a light source, or a series of intermittent bright images that alternate with darkness. Persistence of vision subdues the effect of flicker with moving images when viewed at specific rates. With **PAL** television, working at 50 Hz, the screen is 'redrawn' 50 times per second. However, with **interlacing**, only half of the image is redrawn at each pass, so that there is an effective framing rate of 25 frames per second. Computer **monitors** work at figures between 50 and 80 Hz, and are generally **non-interlaced**, so that the screen is redrawn at a rate of between 50 and 80 frames per second, i.e. each **pixel** is scanned at this rate. If the rate were too low, a flicker effect would result which, as users generally sit quite closc to computer monitors, would become very uncomfortable to look at after a time. The image on a computer monitor is therefore much more stable than one on a domestic television. Generally, a scan rate of 70 Hz and above should give a flicker-free display. Some flickering may become apparent if the brightness level is high, or occasionally may result from a strobing effect from fluorescent lighting.
See also **Vertical scan rate**

Flip
To laterally reverse an image from left to right, or top to bottom.

Floating point unit (FPU)
See **Coprocessor**

Floating selection
When a selection is pasted into an image, it is known as a floating selection until it is deselected, or converted into a **layer**.

Floppy disk (or diskette)

The name given to a 3.5 inch diameter disk used for storing relatively small amounts of computer data. There are two capacities available, *double density* (storing approximately 700 Kb) and *high density* (storing approximately 1.4 Mb).

Floptical

The name often given to a 3.5 inch diameter **magneto-optical** (MO) disc.

FM (frequency modulated screening)
See **Stochastic screening**

Focal length

The distance from the lens (strictly, the rear nodal point of the lens) to the point of focus on the image plane when the lens is focused on infinity. The rays of light entering the lens are thus parallel. The 'standard' lens for any given format is derived from the length of the diagonal of that format:

24×36 mm	=	approximately 50 mm (more accurately 43 mm)
60×60 mm	=	75 mm

Many CCD sensor arrays placed into conventional film cameras are smaller than the film they replace. The dimensions of the 1.5 **megapixel** chip used in the latest Kodak **DCS™** cameras are 14×9.3 mm. This means that the 'standard' focal length for this chip is approximately 20 mm. There is an effective magnification of 2.6 times the focal length when used with 35 mm film.

In an effort to solve the problem, Nikon™ and Fuji™, in a joint venture, introduced a range of digital cameras

61

14mm

9.3mm

24mm

36mm

Figure 8 Diagram showing the difference between 35 mm format film, and the 1.5 million pixel CCD used in many digital cameras. The standard focal length lens for the 35 mm is 43 mm (usually rounded up to 50 mm) whilst the standard for the CCD is 17mm (usually rounded up to 20-24 mm).

in 1995 which use the same CCD sensor, but also contain an optical relay system which reduces the 24 × 36 mm image produced by the lens to the size of the CCD chip. The **aspect ratio** of the chip is 1.28:1, as opposed to 1.5:1 in 35 mm film, so that the horizontal coverage of the lens is 0.85 that which the lens would give on 35mm film. A 50 mm lens from a 35 mm film camera would, in effect, become a 42.5 mm lens on this system.

Focoltone™
A colour matching system similar to **Pantone**™, but less common.

Format

1 The process of preparing a disc for storing
 information. The process creates a 'map' which
 allows the data to be stored, catalogued and
 retrieved in an orderly manner. The disc is divided
 into sectors (segments) and tracks (concentric
 circles), the number of which determines the
 amount of data which can be stored. Generally,
 discs are formatted for a particular computer
 platform, e.g., **Apple Macintosh™** or IBM PC for
 example. On the Macintosh platform, the process
 is known as '**initializing**'.

2 The way in which a file is stored.
 See **File format**

3 The image dimensions in the film gate of a camera.

FPO (for position only)

A low resolution version of an image used to indicate
its placement within a document.

FPU (floating-point unit)

See **Coprocessor**

Fractal

A complex mathematical principle, whereby a geometric
shape has the property that each small portion of it can
be viewed as a reduced scale replica of the whole. Fractal
mathematics are being used increasingly in image
compression routines.
See **FIF**

Frame

Video data is transmitted as two interlaced **fields** which
make up a single frame. In a 50 Hz system, one complete
frame is transmitted every $\frac{1}{25}$ th second.

63

Frame grabber
Hardware that takes the **analogue** signal from either an imaging device such as a video camera, or from tape, then digitizes it for storage in RAM.

Frequency modulated screening (FM)
See **Stochastic screening**

FTP (file transfer protocol)
The method by which software can be downloaded from a remote computer. Many computer companies maintain a free-access FTP site, anonymous FTP, for software upgrades.

Full motion video
Video that plays back smoothly at about 30 frames per second.

Gg

Gamma

In photographic sensitometry, gamma refers to the slope of the straight line portion of the characteristic curve of an emulsion. In digital imaging, it is a measure of the midtone image contrast, the relationship between input data from an electronic image, and output data telling the monitor how to display an image.

Gamma curve
See **Curve**

Gamut

The range of colours (or tones) which can be displayed or printed by a particular colour system. Many programs and colour management systems have 'out of gamut' warnings, indicating when colours displayed on a monitor are not reproducible by the printing system in use.

Gamut mapping

The process of aligning the colour space of one device with another, achieved with **algorithms** or **look up tables (LUT)**.

Gateway

A computer system located between, and connected to, networks using different protocols. It facilitates the exchange of information between networks.

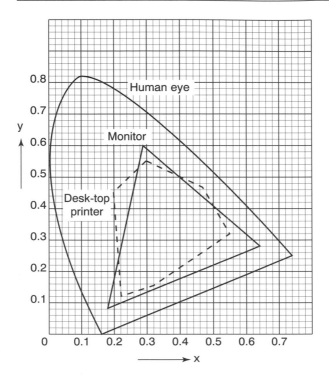

Figure 9 Gamut mapping: the ability of an imaging system to display, or print various colours can be 'mapped' together so that they can be compared. In this diagram, the approximate gamuts of the human eye, a computer monitor, and a typical digital printer are shown.

Gaussian

A mathematical description of a certain type of noise or blur.

Gaussian blur

A filter in image processing programs which blends a specified number of pixels at a time, following the bell-shaped Gaussian distribution curve.

GCR (grey component replacement)
The practice of using black ink in place of cyan, magenta and yellow in combination.

Generation
Successive copies of data are known as generations. With analogue systems, there is often some loss of data between one generation and the next, but with digital systems, there is no loss of data between generations.

GIF (graphics interchange format)
An image **file format** developed in 1987 by Compu-Serve™ for compressing 8 bit images with the aim of transmitting them via **modems**. It defines a protocol for the on-line transmission and interchange of raster graphic data. GIF uses **LZW compression** but is limited to 256 colours. It is independent of the platform used either in the creation of the file or the display.

GIF 89a
The 89a version of **GIF**, introduced in 1989, allows image transparency when used in **Web** pages on the **Internet**. It also allows progressive rendering of an image, whereby a low resolution of an image appears first, followed by increasingly higher resolution until the final version appears. The format also allows the user to store a sequence of still images which can be cycled to produce an animation effect – **Animated GIF**.

Gopher
A utility which enables users to search for, view and retrieve information from servers on the Internet.

67

Gradation
A gradual change of tone or colour.

Green Book
The standard for **CD-I** discs, containing audio, graphics, animations, full motion video and other data. It is aimed at multimedia applications, and is designed to address the problem of synchronizing the various data tracks on the same disc.
See also **Colour book standards**

Grey balance
The balance necessary between cyan, magenta, yellow and black printing inks, or red, green and blue sensors to achieve a neutral grey without a dominant colour **cast**.

Grey ramp
A curve that defines the use of black ink in colour separations.

Grey scale
Strictly, a grey scale is a scale of values of neutral grey tones, from black to white, with an infinite range of greys in between. A grey scale 'step wedge' is a specific number of grey tones between black and white.

Grey scale mode
Displaying an image in 8 bit mode i.e. black, white and 254 shades of grey.

GUI (graphical user interface)
A computer interface such as the **Apple Macintosh**™ operating system, or Microsoft **Windows**™, which uses graphical icons to represent computer functions.

Hh

Halftone

The process of printing continuous tone images by simulating a continuous tone with a series of dots of varying sizes.

Halftone contact screen

A sheet of glass or film ruled with opaque lines, which, when printed in contact with an original image, produces a dot pattern, enabling continuous tone images to be printed with just black ink, or four inks for colour reproduction.

Halftoning factor

See **Q factor**

Halo

A pale line around object edges, often caused by excessive **unsharp masking (USM)**.

HAM (hold and modify)

A variation of Amiga's **IFF™** format supporting compressed images.

Handles

The small rectangles which appear at the corners and edges of the screen image of an object when it is **selected**. The handles can be dragged to change the size or shape of the object.

Hand scanner
An inexpensive reflection **scanner** based on a **linear array CCD**. The scanning action is carried out by moving the scan head manually over the print surface. An uneven rate of scan can lead to uneven image density. They are generally low resolution, and not often used for professional imaging.

Hard copy
A print or transparency.

Hard disc
The term used either for an internal or external rigid disc used for reading and writing computer data. Many different capacities are available, from 44 Mb to 1 Gb and over, and include several types which are encased in plastic, which can be removed from the drive mechanism (e.g., **Syquest™**, **Zip™**).

Hardware
The individual physical components of a computer system, including the CPU, monitor, keyboard, etc.

HDTV (high definition television)
High resolution television system containing about twice the number of scan lines (1000 or more) of present **NTSC**, **SECAM** and **PAL** standards.

Hertz (Hz)
A unit of frequency, equal to one cycle per second (cps). One kilohertz (KHz) equals 1000 cps, one Megahertz (MHz) equals 1 million cps.

Hexachrome™
A relatively new printing process based on **stochastic**

screening, and using six printing inks – CMYK plus orange and green. It is capable of reproducing more colours on the printed page than traditional four colour printing.

hi-fi™ printing
A relatively new printing process based on **stochastic screening**, and the use of seven printing inks – CMYK, plus red, blue and green. It is capable of reproducing more colours on the printed page than traditional four colour printing.

High end
A term generally used for any part of the imaging chain (**scanner**, **computer**, **output** device) utilizing very high resolution files, usually destined for large posters, and high quality magazine reproduction. Computer systems such as Quantel™ and Barco™ are high end systems, usually using input from **drum scanners**, or high resolution **digital cameras**. Such systems are relatively very expensive.
See also **Low end**

High key
An image composed primarily of light tones.

Highlight
The brightest part of an image that is not a **specular highlight**.

High pass filter
A filter which sharpens an image by accentuating high spatial frequency detail.

High Sierra Standard
A standard for defining the way data is arranged in the tracks and sectors of **CD ROMs**. It was adopted by the

International Standards Organisation as **ISO 9660**. It defines the requirements for reading CDs on different computer platforms.

Histogram
A graphical representation of an image showing the distribution of grey or colour levels or values within an image.

Histogram sliding
The addition of a constant brightness value to every pixel in an image. The effect is to 'slide' the histogram to the left or right.

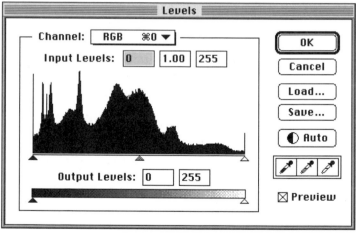

Figure 10(a) Histograms are a graphical representation of the distribution of tonal values within an image: (a) shows a histogram for an 'average' image, showing an even distribution of tones across the histogram. (b) shows a histogram for a 'low key' image, showing a predominance of tones in the dark grey and black end of the histogram.

72

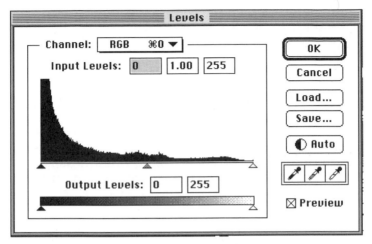

Figure 10 (b)

Histogram stretching
Multiplying by a constant value every pixel in an image. The effect is to stretch or shrink the histogram.

HMI (hydrargyrum medium arc iodide)
A specialist type of metal vapour light source which has a continuous and flicker free output, and is recommended for certain scanning types of **digital camera**. It has a **colour temperature** of approximately 5600 K, similar to daylight.

Home page
The opening introductory screen of a **Website**. The home page may contain an index of other pages, or links to other areas of the site.

73

HSB colour model (hue, saturation and brightness)
In **Adobe Photoshop™** and other image processing programs, a colour wheel is used to display possible image colours. *Saturation* is the strength or purity of the colour or *hue*. It represents the amount of grey in proportion to hue, and can be expressed as a percentage: 0 per cent (grey) to 100 per cent (fully saturated). Fully saturated colours are shown around the perimeter of the wheel. The centre of the wheel represents lowest saturation. *Brightness* is the lightness or darkness of a colour. Zero brightness equals black. Full brightness combined with full saturation results in the most vivid version of a colour.

HSL colour model (hue, saturation and luminosity)
Similar to the **HSB** colour model. Zero luminosity equals black, but full luminosity equals white. Thus, vivid versions of colour require medium luminosity. This mode is no longer included within **Adobe Photoshop™**.

HSV (hue, saturation and value)
The same as **HSL**.

HTML (hypertext mark up language)
This is the computer language used by the **World Wide Web** for constructing pages with information. This data can be text, images, etc., which can be 'linked' to other pages. Many software packages such as Microsoft Word™ have HTML editing facilities.

HTTP (hypertext transfer protocol)
The search and retrieve **protocol** used for transferring hypertext files across the Internet.

Hue

The wavelength of light reflected from or transmitted through an object. It is identified by a name, e.g., red, green, or by a dominant wavelength.

Huffman compression
See **Huffman encoding**

Huffman encoding

A type of run length encoding (**RLE**) used in **lossless data compression**.

Hybrid disc

1 A **CD** containing software and data in both IBM PC and **Apple Macintosh™** formats.
2 A recordable CD on which one or more **sessions** have been recorded, but which has not been 'closed', thus allowing the possibility for future recording.

Hybrid imaging

An imaging system using a combination of silver based and digital technologies. Examples include the **advanced photographic system (APS)**, and **PhotoCD**, where silver based film is scanned onto **CD ROM**.

Hypermedia

Information in electronic form which links to other media.

Hypertext

Text that contains a link to another piece of text or information. Hypertext words are usually in a different colour in documents.

Ii

IBM compatible personal computer (IBM PC)
Any personal computer capable of running Microsoft **DOS** or **Windows™** applications.

IBM (International Business Machines)
A prominent manufacturer of personal computers.

IC (integrated circuit)
A semiconductor circuit that has more than one transistor and other electronic components, and can perform at least one electronic circuit function.

ICC (International Colour Consortium)
A group of eight industry vendors, established in 1993, for the purpose of creating, promoting and encouraging the standardization and evolution of an open, vendor-neutral **colour management system**.

Icon
A symbol on a computer monitor representing an operation, or group of operations.

IFF (Interchange File Format)
A native image file format used by Amiga™ computers.

Image analysis
A set of tools to enable measurements and other data to be taken from images. The analysis may be of

morphology (size or shape), *intensity*, *density*, *texture* or *reflectance* of the subject matter. Image analysis software can also be used to make information within images easier to see.

Image Magic™
The generic name given to a range of services and equipment from Kodak™ aimed primarily at amateur photographers wanting to view or process images on home computers. It includes a scanning service for transferring photographic film to either floppy disc or compact disc (Picture Disc™), print services, and enhancement and manipulation services. The **FlashPix** file format is used. Many of the services are available via the **Internet**.

Image Pac
The Kodak **PhotoCD** system of storing image data that contains all resolutions from **64Base (Pro-PhotoCD)** through to **Base/16**. Image Pacs on Master PhotoCD's will only contain 16Base to Base/16. The information for the 64Base image is held in the **Image Pac Extension (IPE)**.

Image Pac Extension (IPE)
See **Image Pac**

Image processing
Techniques that manipulate the pixel values of an image for some particular purpose, e.g., to correct brightness or contrast, to change the size (scaling) or shape of images, to enhance detail, or to enable scientific analysis of image data.

Image resolution
See **Resolution**

Imagesetter
A high resolution device producing output on film or photographic paper usually at resolutions greater than 1000 dpi. Usually a **PostScript™** device.

IMG
A standard bitmapped image format used by programs running under the GEM™ windowing environment.

Indexed colour
A single-channel image with 8 bits of colour information per pixel. The index is a **CLUT** containing up to 256 colours. This range of colours can be edited to include only those found within the image. Digital images used in **multimedia** programs are often in indexed colour mode.

Index print
A page of small, low resolution, numbered **thumbnail** images used as a visual reference for the contents of a **PhotoCD**.

Information exchange (IX)
A system built into the **APS** system for the communication of information about such data as exposure or the use of flash between film, camera and photofinishing equipment.

Infrared
Electromagnetic radiation with wavelengths from approximately 700–900 nm. **CCD** sensors are inherently sensitive to infrared radiation, and many are supplied with infrared absorbing filters to minimize or remove its effects.

Initialize
The term used with **Apple Macintosh™** computers for the formatting of discs.

Ink jet printer
This is currently the cheapest form of computer printer for colour **hard copy**, although **high end** ink jet printers, such as the Iris™ range are available, capable of producing near photographic quality prints at large sizes. The colour system uses four cartridges to provide cyan, magenta, yellow and black ink. The cartridge contains **liquid ink** which is forced into a tiny nozzle either by the application of heat or pressure. As the ink heats, it forms a tiny bubble at the end of the nozzle, hence the common name of **bubble jet** printers. All ink jet printers work best with dedicated coated paper types, as the absorbency of the paper controls the brightness and definition of the image. It is possible to use good quality 'art' paper for exhibition purposes. Although the printing process is relatively slow, the technology has the advantage of working at any size and by a process of scaling up the transport mechanism and the size of the nozzles, printers can be made to output prints up to A0 size and larger. Another method of ink delivery is the **phase change ink jet**, generally employed in relatively expensive printers.

Input
Any data entered into a computer.

Insertion point
See **Cursor**

Instruction set
A group of instructions within the **CPU** of a computer

to handle various tasks. **CISC** processors contain a wide variety of instructions to handle many different tasks. **RISC** processors contain only those instructions needed most often. When a complex instruction is needed, the RISC processor builds it from a combination of basic instructions.

Integration time
The exposure given to picture elements on a CCD.

Interference filter
Also called **dichroic filters**, these filters look like coloured mirrors. They transmit one colour and reflect another, complementary colour. For example, one type may transmit green and reflect magenta light. They work not by absorbing unwanted wavelengths of light, but by interference effects within the coating of multiple thin layers of the filter.

Interlacing
A television scanning system where the two sets of lines in each pair of fields are displaced vertically so as to alternate with each other (see Figure 11).

Internet
A worldwide network which links computer systems together, using the TCP/IP protocols.
See **World Wide Web**

internet
The connection of two or more computer networks.

Interpolation
A method for increasing the *apparent* resolution of an image whereby the software used mathematically

Video Interlaced Scan Pattern

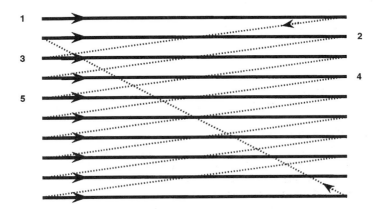

Two Fields equals one frame

525 Lines NTSC **625 lines PAL**

Figure 11 Video interlaced scan pattern. After completion of one scan, to form a 'field', the beam 'flies back' to scan another field, interlaced between the lines of the first. Two fields together give one video 'frame'.

averages the densities of adjacent pixels and places a pixel of that density between the two. There are various methods of interpolation including **nearest neighbour, bicubic** and **bilinear**. Excessive interpolation may result in images with a blurred, unsharp appearance.

I/O
The standard abbreviation for input and output.

Ion™ (image online network)
The name of the first consumer **still video** camera system, introduced by the Canon Corporation™ in 1989.

81

IP address
A unique numeric representation of the location of a computer within a network. It consists of four sets of numbers separated by periods (sometimes called a **dotted quad**, e.g., 135.123.245.9).

IPE (Image Pac Extension)
The **64Base** component of the **Pro-PhotoCD** format is stored in a separate directory, known as the Image Pac Extension on the disc, and accessed when required by specific acquisition software.

ISDN (Integrated Services Digital Network)
A telecommunications standard allowing digital information of all types to be transmitted via telephone lines. It can provide data rates of up to 128 000 bits per second.

Ishihara colour test
A set of standard colour charts which are used to diagnose defective colour vision and other deficiencies in human colour perception.

ISO (International Standards Organisation)
A worldwide federation of national standards bodies.

ISO rating or speed
The rating applied to photographic emulsions to denote their relative sensitivity to light. The **CCD** sensors used in digital cameras have **equivalent ISO ratings**, to enable comparison with film materials.

ISO 9660
An international standard specifying the logical file format for files and directories on a **CD ROM**.

See **High Sierra**

ISP (Internet Service Provider)
A commercial company which provides access to the **Internet**, usually for a fee, e.g., CompuServe™.

IT8
An industry standard colour reference chart used to calibrate scanners and printing devices.

IVUE file
The **file format** used by the **Live Picture™** image processing software program to work with its **FITS** technology. Image editing actions are stored mathematically in a FITS file, while the original pixel data is saved in the IVUE format. A new output file is created from the original IVUE image based on the FITS file in a single, final **RIP** process that avoids cumulative proccssing errors. The major advantage of this file format is its ability to deal only with that portion of an image being edited, thereby greatly speeding screen display between edits. An IVUE file is generally approximately 25 per cent larger than the original **TIFF** file.

IX
See **Information exchange**

Jj

Jaggies
See **Aliasing**

Jaz™ drive
A removable hard disc system using 3.5 inch diameter discs of 1 Gb capacity.

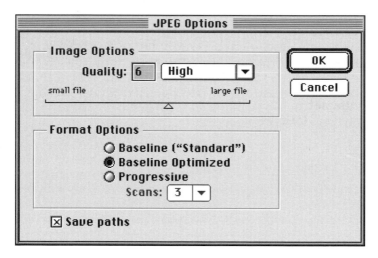

Figure 12 The JPEG dialog box in Photoshop 4, showing the options available when saving files, including 'progressive JPEG' for Web applications.

JFIF (JPEG file interchange format)
A data **file format** which enables JPEG bitstreams to be exchanged between a wide variety of computer platforms and applications.

JPEG (Joint Photographic Experts Group)
A set of specifications for a widely used **lossy compression** routine as used for still photographic images. Users can specify the amount of compression used, when saving the image (see Figure 12).

Progressive JPEG
Allows successive rendering of an image, whereby a low resolution rendering of an image appears first, followed by increasingly higher resolution until the final version appears. It is widely used in **Web** pages on the **Internet**.

Jukebox
A device for holding a large number of **PhotoCDs**, any one of which can be readily accessed, thus forming the basis for an image library system.

Julia set
A type of **fractal**.

Kk

K

1 (Abbreviation **Key**) The process ink colour black used in four colour printing.

2 The quantitative scale used to define the spatial resolution of **film recorders**.

Kai's Power Tools™
See **KPT**

Kernel
A group of pixels used in a **convolution** process.

Kerning
The process of adjusting the space between two adjoining alphanumeric characters to optimize their visual appearance.

Key
See **K**

KPT (Kai's Power Tools™)
A series of **plug-in filters** for **Adobe Photoshop™**. They include *special effects filters*, *texture generators* and *fractal pattern generators*.

Ll

LAN (local area network)
An information network formed by the linking together of computers and peripheral devices such as printers, within a small geographic area such as a room, or single building.

Land
The surface of the reflective layer of a **compact disc (CD)**.

Laplacian filter
An image processing **filter** which selectively enhances edge detail in one direction.

Laptop
A term given to a small portable computer. Many are now powerful enough to run image processing programs, and are used extensively by photographers for editing images 'in the field' before transmitting them via **modems** to newspapers and the like.

Laser (light amplification by stimulated emission of radiation)
A light source emitting an intense directional beam of coherent, monochromatic light or radiation.

Laser disc
A 300 mm (12 inch) diameter optical disc used for storing video images and sound data in an **analogue** format.

Laser printer

A printer containing a rotating metal drum coated with a fine layer of photosensitive material. An electrostatic charge is applied to the whole drum. This charge on the drum can be removed by applying a light to its surface. The image to be printed is applied to the drum via a modulated laser beam or row of **LEDs** (light emitting diodes). A negative image of the subject to be printed is drawn progressively onto the surface of the drum. The result of this is to 'undraw' the image on the drum as it rotates, a process similar to producing a statue by chipping away all pieces of stone until the statue is complete. The end result of the operation is to leave an 'image' of the original as electrostatic charge on the drum. The drum rotates past a dispenser containing toner. The ink used has an electrical charge and is attracted to the charged image on the drum. This toner image can then be transferred on to plain paper by giving the paper an opposite electrical charge. The toner is then attracted from the drum onto the paper, giving a black toner image on the paper, after fusion by heat. The light source scans across the surface of the drum forming the image by a series of overlapping individual dots. The minimum size of a dot is the width of the light beam as it is focused on the drum. This means that all images are formed by multiples of a single dot size. Note that the dot size does not change as larger dots can be formed by groups of overlapping dots. Colour laser printers use four drums, and form image colours using cyan, magenta, yellow and black components.

Lasso

The lasso **tool** used in image processing programs such as **Adobe Photoshop™** allows the user to draw a freehand **selection** around parts of an image.

Layer

A feature of **Adobe Photoshop™**, and other similar image processing programs, where the original image is known as the 'background'. Other images, or versions of the original image, can be overlaid on the top of the background image as 'layers'. Large numbers of layers can be stacked on top of the background, and individual layers can be adjusted in terms of their opacity and the like, or moved in relation to the background.

LCD (liquid crystal display)

A technology used particularly for screens on portable **laptop** computers, and small preview screens on digital cameras. A liquid crystal is a semi-liquid, gelatine-like crystal of organic molecules, which change their configuration when they receive an electrical voltage. This change affects the transmission of polarized light, and hence brightness. The screen of an LCD monitor display is composed of thousands of tiny cells forming pixels, and each receives a signal which makes it transmit more or less light from a backlight behind the screen. Colour filters may be incorporated over the cells to synthesize colour images. There are two basic types, namely **passive matrix LCD**, and **active matrix LCD**.

LCLV (liquid crystal light valve)

A technology for producing continuous tone colour prints and transparencies on silver-based photographic media. Digital image data is written by laser onto three LCLV cells, and then the composite image is projected by tungsten light onto photographic media and then processed.

LED

See **Light emitting diode**

Levels

A term used in image processing programs such as **Adobe Photoshop**™ for the dialog box containing the image **histogram**, and related controls over the input and output values of the image.

Light emitting diode

A semiconductor diode which emits light (or infrared radiation) when a current is passed through it. The visible colour, usually red, green or orange depends on the type of semiconductor used, and the colour of the transparent housing in which the LED is placed.

Lightness

The value of tones in relation to a scale of greys. Whites are greys of high lightness, blacks are greys of low lightness. In prints, highlights are tones of high lightness and shadows are tones of low lightness.

Linear

A system where the output is directly proportional to the **input**.

Linear array CCD

A single row of **picture elements** which is used to traverse across the image projected by a lens (in a digital camera), or across a print or transparency, thus **scanning** it in order to convert analogue information into digital data. **Resolution** is quoted as number of pixels or elements per inch or centimetre. Tri-linear CCDs have three lines of picture elements each coated with a primary filter i.e. red, green and blue.
See also **CCD**

Line art
The term given to diagrams and images consisting of black lines on a white background, or vice versa (i.e. **binary**).

Line pairs per millimetre
See **Resolving power**

Line time
The time taken by a **linear array CCD** to scan across a projected image and record a single line of pixel data.

Liquid ink jet
A method of **ink jet printing** that propels fine droplets of liquid ink onto the receptor paper surface. This may lead to the ink soaking into the fibres of the paper, and being wet for some time after the printing process has finished. This method is generally used in relatively inexpensive ink jet printers.

Live Picture™
An image processing and editing program which uses **FITS** technology, enabling users to manipulate and work with very large image files, perhaps 200 Mb, in almost **real-time** using a relatively small desktop computer. Before processing, images are converted into the **IVUE** file format. From this file the program creates a **view file** at a screen resolution of 72 dpi so that the largest image, even on a 21 inch monitor, will only take up a maximum of 2.2 Mb. All processing is carried out on this image, and is performed very quickly, with virtually no delay. As changes are made, a list is compiled in a file known as a **FITS**. This list is applied to the on-screen image during editing – the original remains untouched.

When completed, the alterations recorded in the FITS file will be applied to the IVUE file, producing a TIFF file. This can then be generated at a specific resolution, dependent on the output device being used. This **post processing**, or **building** of the image may take several minutes.

Look up table
See **LUT**

Lossless compression
A data compression routine in image processing which does not sacrifice data in the process. This type of compression looks for patterns in strings of bits, and then expresses them more concisely. It uses techniques of **run length encoding** to compress the data into a more concise format. An example of run length encoding is used by **Huffman compression**, or **Huffman encoding**. This assigns patterns with a code – the most frequently used patterns are assigned the shortest code. (This is similar to the Morse Code where the commonest letters are assigned the shortest codes, and the least common the longest, e.g., E = dot, Z = dash, dash, dot, dot). However, because digital documents vary in their type, so the Huffman code must create a new set of codes for each document.

As an example, the words DIGITAL IMAGE can be processed as follows:

character	frequency
D	1
I	3
G	2
T	1
A	2

L	1
M	1
E	1

This can then be coded as follows:

character	frequency	Huffman Code
I	3	0
A	2	00
G	2	01
D	1	110
E	1	111
L	1	000
M	1	001
T	1	101

Huffman works best with text files, and variants of it are used in certain FAX machines. Whilst it does work with images, it requires two passes of the data, the first to analyse the data and build the table, the second to compress the data according to the table. This table must always be stored along with the compressed file. Because of the way Huffman encoding analyses the data the process is known as a 'statistical compression method'. A refined version of it which uses a 'dictionary method of compression' is called **LZW compression** – an integral part of the **TIFF** file format. At the beginning of the file, LZW starts a small table, like the Huffman compression. It then adds to this table every new pattern it finds. The more patterns it finds the more codes can be substituted for those patterns, resulting in greater compression. It does this in one pass resulting in greater speed. LZW can compress images up to 10:1. Another format which uses LZW compression is **GIF**, used by

CompuServe for compressing 8 bit images for transferring through networks.

Lossy compression

A data compression routine such as **JPEG**, which sacrifices data in the process. It relies on the fact that the human eye is much more sensitive to changes in brightness (luminance) in an image than to colour (chrominance). The image data is separated into luminance and chrominance, and lossy compression algorithms are then applied to the chrominance data. (This is similar to television, where a medium resolution monochrome signal is overlaid with a low resolution colour signal.)

Users have the opportunity to determine the level of compression at the time of saving the file. In general, the higher the compression, the lower the image quality. Images heavily compressed with JPEG are characterized by a 'blocky' appearance in areas of flat tone. The amount of data lost may or may not be noticeable, depending on the final use of the image.

Low end

A term often used to describe imaging systems using relatively inexpensive types of flatbed and film scanners, desktop computers and output devices. The file sizes handled are usually lower than in **high end** systems, and the quality of work may not be good enough for the very highest reproduction requirements. Increasingly, the differences between high end and low end systems are becoming smaller.

Low key

An image composed mainly of dark tones.

Low pass filter
A filter used in image processing which smooths or blurs an image by attenuating high spatial frequency detail.

lpi (lines per inch)
The scale used by printers to specifying a halftone screen used in a printing process. This book uses a screen with 133 lines per inch.

Luminance
1 A quantitative measure of the brightness of a surface emitting or reflecting light.
2 In video, the part of the output signal which determines the brightness of an image. Usually denoted as 'Y', as in **YCC**.

Luminance signal (also called the **Y signal**)
See **Luminance**

LUT (look up table)
A preset number of colours used by an image (sometimes called **CLUT** or colour LUT).

LZW (Lempel-Ziv-Welch)
A **lossless compression** routine developed in the 1970s, and incorporated into the **TIFF** and **GIF** file formats.

Mm

Mach band
An optical illusion whereby dark and light zones or bands are seen at the edges of uniformly lit areas of colour or density.

Macintosh™
See **Apple**

Magic wand
A selection **tool** found in image processing programs such as **Adobe Photoshop™**, which automatically selects a contiguous area of similarly coloured or toned **pixels**.

Magneto-optical disc drive
This data storage system utilizes a **laser** beam, which is focused down onto a small area of a layer on the disc composed of crystalline metal alloy just a few atoms thick. The laser beam heats the spot on the alloy past a critical temperature, at which the crystals within the alloy can be rearranged by a magnetic field. A 'write' head similar to that found in conventional magnetic disc drives aligns the crystals according to the input signal being sent. A 'read' head then detects the orientation of the crystals to provide the output signal.

Two different sizes of disc are available, 5.25 and 3.5 inch, in various storage capacities including 128 Mb, 230 Mb, 650 Mb, and 1.2 Gb. These devices take about

twice as long as conventional disc drives to record or read data, but the discs are relatively inexpensive.

Mandelbrot set
A type of **fractal**.

Mapping
The process of transforming image input brightness into output brightness.

'Marching ants'
An animated line surrounding a selected area of an image in an image processing program to highlight the area.

Marquee
The name given in image processing programs such as **Adobe Photoshop™** to the rectangular, square, elliptical or circular area enclosed by an animated line drawn by selection **tools**.

Mask
The action of delineating a selected part of an image, so that an image processing effect can be applied either to the selected area, or to the non-selected area.

Matchprint™
A system devised by the 3M™ company which uses a system of creating four colour (CMYK) separations using the same data that will generate the final printing plate. Each separation image is placed on the relevant coloured laminate and the resulting sandwich then exposed to ultra-violet light. The coloured laminate softens when exposed to the light and a processing stage is applied to remove the softened areas, leaving a positive image

of each layer constructed of the same dots as the printed page. The process is applied in turn to the four layers of coloured laminate which are then bound in register and sealed.

Maths coprocessor
See **Coprocessor**

Matrix array
See **Area array CCD**

MAVICA™ (magnetic video camera)
The name given to the first **still video** camera, produced by Sony in 1981. Up to 50 images in analogue format could be recorded onto a 50 mm floppy disc.

Median filter
A **noise**-filter found within image processing programs. The filter searches the radius of a selection of pixels, and replaces the centre pixel with the median brightness value of those around it.

Megahertz (MHz)
See **Clock speed**

Megapixel
One million pixels.

Menu
A drop down list of computer commands and functions.

Metamerism
A visual phenomenon whereby two colours may appear the same under certain lighting conditions, and different

under others. Colours exhibiting this feature are known as *metameric pairs.*

Mexican hat filter
An image processing filter found in scientific analysis programs which can detect edges, and **smooth** the image in one operation.

Mezzotint
A screening technique that uses dots that are the same size or larger than those used in conventional screening, but are of random size and frequency. It is usually used for artistic effect. **Adobe Photoshop™** has the facility for producing mezzotints with a specific **filter**.

Middletones
The mid range of tones within an image.

MIPS (millions of instructions per second)
A measure of the processing speed of the **CPU** of a computer.

MIRED (micro-reciprocal degree)
See **Colour temperature**

MMX
A refinement to the **Pentium** series of microprocessors to improve the multimedia capabilities of the computer.

MO
See **Magneto-optical disc drive**

Mode
A term used in image processing programs such as

Adobe Photoshop™ for the type of image, e.g., **RGB**, **CMYK**, **duotone**, **indexed colour**.

Modem (MOdulate and DEModulate)

A device used to transmit and receive data using telephone lines. It converts **digital** signals into **analogue** data from the sending computer, and converts analogue data back into digital form for the receiving computer.

Moiré

A repetitive interference pattern of 'fringes' caused by overlapping grids of dots or lines having different frequencies or angles. A moiré pattern may result when scanning a screened original. Halftone screens must be set at specific angles to each other to prevent moiré patterns.

Monitor

The display screen on which computer data is viewed. Most are based on **CRT** technology, but many computers, such as **laptops**, use **LCD** technology. In the CRT type, three electron guns (one for each of the three colours, red, green and blue) scan the screen and emit a stream of electrons at the screen in proportion to the intensity of the signal received from the digital to analogue converter in the computer. This device compares the digital values sent by the computer to those in a **look up table** which contains the corresponding voltage levels needed to create the colour of a single pixel. With a **VGA** monitor, 256 values are stored in the converter's memory. As the electrons strike the phosphors coated on the inside of the screen so light is emitted. Three different phosphor materials are used, for red, green and blue light. If a group of RGB phosphors is struck by three equally intense beams of

electrons, then the result will be a dot of white light. Different colours are created when the intensities of the beams are varied. Important considerations for imaging are the size of the monitor, the number of colours which can be displayed on a monitor (**bit depth**), and the sharpness of the image (**spatial resolution**). When running imaging programs such as **Adobe Photoshop™**, it is assumed that **photo-realistic** images are required. Photo-realism is a qualitative term which is used to describe how closely a digital image matches the photographic original.

With **bit depth**, for a photo-realistic display, a minimum of 16 bits (32 768 colours) per pixel (i.e. **bit depth**) is required, and preferably 24 bit (16.7 million colours) to give photographic quality images, although, if the budget is limited, 16 bit displays are almost indistinguishable from 24 bit displays with most images. (The bit depth of an image refers to the number of grey shades, or colours which a monitor can display. An 8 bit system can display 2^8 (256) greys or colours. A 16 bit system can display 2^{16} colours (32 000) whilst a 24 bit system can display 2^{24} colours (or 16.7 million). Strictly, the monitor cannot display this number of colours at one time, but it is the number of colours stored in the LUT. It is really those images with areas of graduating intensity (e.g. graduated backgrounds on still life pack shots) that the difference between 16 bit and 24 bit becomes important. It is generally held that at least 160 levels for each of the three colour channels is required to show a continuous gradation without a **banding** effect (i.e. a 24 bit display).

Morphing
An image processing technique, primarily used in the film and video industries for transforming

(meta*morph*osing) one image through a series of steps into another. For example, the film 'Terminator II' showed a blob of molten metal gradually morphing into a human figure.

MOS (metal oxide semiconductors)
Highly efficient, but expensive light sensitive sensors that can be used as an alternative to **CCD**s.

Mosaic colour system
A colour system in which colours are formed by the additive mixing of light from adjacent areas that are generally too small to be resolved individually by the naked eye. An example is colour television, where all colours are formed from the combination of outputs from red, green and blue phosphor dots.

Mosaic filter array
See **Colour filter array**

Motherboard
The main circuit board in a computer which houses the central processing unit (**CPU**), **RAM** and **ROM** chips and various other components.

Mottling
A usually undesirable texture pattern which may sometimes appear after sharpening an image. It is most prevalent in areas of flat tone such as sky.

Mouse
The hand-operated pointing device connected to the computer for moving a **cursor** around the screen, and for selecting items from the menus by means of one or more click switches, as well as other functions.

MPC (multimedia personal computer)

The standard for **multimedia** set by the vendors who joined together to form the Multimedia PC Marketing Council.

MPEG (Motion Picture Experts Group)

Like **JPEG**, an acronym used to identify a standard **compression** routine, used primarily for digital video, audio and animation sequences.

MS-DOS

See **DOS**

Multichannel mode

An image mode used within **Adobe Photoshop**™ and other imaging programs. It is formed when adding a new **channel** to a greyscale image. Multichannel images use 8 bits per pixel, and are used for specialized printing purposes such as printing a greyscale image with a **spot colour**.

Multimedia

The combination of various media, e.g., sound, text, graphics, video and still photography, into an integrated package.

Multisession discs

A **CD** written in more than recording session. Multi-session discs can only be read in a multi-session CD player.

Munsell colour system

A widely used **colour space** model, using the attributes hue, chroma and value. It is based upon human colour perception and the visual differences of the three attributes.

Nn

Native file format
The file format used to save data by specific application programs. For example, **Adobe Photoshop™** uses its own Photoshop format, which slightly compresses data when saving. Native file formats must be used in order to store information regarding layers, etc., and when the data is to be reread by the same program. They generally should not be used for transferring files into other applications such as desk top publishing.

Nearest neighbour
A method of **interpolation** whereby in order to increase resolution, the value of the new pixel is determined by giving it the same value as its nearest neighbour. This is the quickest, but least accurate form of interpolation.

Near letter quality (NLQ)
See **Dot matrix printer**

Netscape™
A popular World Wide Web browser program.

Network
Two or more computers connected together for the purpose of exchanging data.

Newsgroup
Discussion groups on the Internet where subscribers can discuss topics, post questions and send answers to others.

Newton Rings
The undesirable appearance of colour fringed circles.
They may appear in scanned images, where the original
has not been in close enough contact with the drum or
glass platen. They are also common when projecting
colour transparencies in glass mounts

Node
A computer system which is part of a network.

Noise
Random, incorrectly read pixel data, or extraneous
signals generated by a **CCD**, even when no light is falling
on it. May be caused by electrical interference.

Noise filter
A selection of filters found in image processing programs
such as **Adobe Photoshop™** which reduce the effects
of **noise**. Some programs also have *add noise* filters
which apply random pixels to an image, for creative or
graphic effects.
See **Median filter**

Non-impact printer
A printing device which prints information onto the
receiving surface without coming into physical contact
with it. Examples are **ink jet** and **laser printers**.

Non-interlace scanning
A process used in some new high quality television sets,
and some computer monitors, whereby each scan line
is transmitted in sequence, rather than the trans-
mission of odd and even lines in separate scans. The
system leads generally to sharper images on screen.
See **Interlacing**

NTSC (National Television Standards Committee)
The broadcast TV standard principally used in the USA and Japan. It specified 525 lines, 60 fields and 30 frames per second (strictly 29.97 fps).

Nubus
The **bus** used in **Apple Macintosh™** computers.

Nyquist criterion
The minimum frequency at which a continuous waveform must be sampled in order for it to be accurately reconstructed from discrete sampling data. This frequency is greater than twice the maximum frequency present in the analogue waveform. If the waveform is sampled at a lower frequency, then the undersampled frequencies will be aliased, and the lower frequencies will show distortion.

Oo

Object-oriented
A term used to describe a graphics application, such as **Adobe Illustrator™**, which uses mathematical points (**bezier points**) based on vectors to define lines and shapes in the image.

OCR (optical character recognition)
Software which, when used in conjunction with a digital scanner, converts pages of typescript text into editable computer data.

OLE (object linking and embedding)
A system developed by Microsoft™ for exchanging data between applications.

Opacity
The ratio between the amount of light falling upon a film sample, to that transmitted by it.

Open flash
A technique whereby the camera shutter is opened in a totally dark environment, and the exposure is made by firing one or more flashes. It is often used, for example, in high speed photography where the time taken for the shutter to open would be too long for the event being photographed.

Operating system
See **OS**

Optical character recognition
See **OCR**

Optical disc
A disc used for storing digital data which is written to, and read from, by a laser. They are generally used for storing large volumes of data.

Optical media
See **Optical disc**

Optical resolution
The 'true' resolution of a scanner i.e. the actual number of sensor elements present in the **linear array CCD** chip. The resolution of a scanner can be increased through **interpolation** techniques.

Orange Book standard
There are two parts to this standard. Part one deals with **CD-MO** drives, whilst part two deals with **CD-WO** discs. The Orange Book also specifies standards for multi-session recording.
See also **Colour Book standards**

OS (operating system)
A series of computer programs which enable other programs to run on the computer. It creates an environment enabling different programs to perform functions such as *saving, printing, displaying* lists of stored files and *deleting*. Without an operating system, each program would need to have these functions built-in. The ability to cut and paste items between programs is an integral part of the operating system of the computer. Examples are Microsoft **DOS™**, and **Apple**'s System 7™.

108

Output
The way in which a digital image (or other digital file) is viewed. Examples are prints of various types, or transparencies.

Overscanning
The capture of more grey tones or colours than is actually required for the particular output device to be used. The additional data can be used to increase the highlight or shadow detail.

Pp

Page description language
See **PDL**

Paint program
A graphics program which defines images in terms of **bitmaps** rather than as **vectors**.

PAL
The television standard used in the UK, and much of Western Europe. It uses 625 lines with 50 fields and 25 frames per second. Of the 625 lines transmitted, 576 are used for the pictures signal, and 49 are used for other data such as teletext and control signals.

Palette
A menu giving selections of colours, tones, or image processing **tools**.

Pantone™
A widely used colour reference system.
See **PMS**

Parallel port
The parallel port socket in a computer is often referred to as the *Centronics port* and is most often used for connecting to a printer. Parallel ports have eight parallel wires which send eight bits (1 byte) of information simultaneously, in the same amount of time which it takes a serial port to send one bit. One drawback with the system is that of **crosstalk** where voltages leak from one line

to another, causing interference to the signal. For this reason, the length of parallel cables is limited to approximately 3 metres (10 feet). Most PCs have both **serial** and parallel ports. The **Apple Macintosh™** computer generally has one or two serial ports, one for the printer, one for a **modem**, and another port called a **SCSI** connection.

Parity
A form of error checking when transmitting data.

Passive matrix display
In this type of **LCD** display, relatively few electrodes are used along the liquid crystal layer. The charges fade rapidly, leading to desaturated colours.

Paste
To take an item held in the computer memory, and place it into another file, or into another part of the original file.

Path
A path is any line or curve drawn using the pen **tool** in programs such as **Adobe Photoshop™**. This tool can be used to draw smooth edged paths, defining areas to be filled, or for drawing complex shapes. The path is composed of a number of points, linked together by straight lines. These lines can be curved into any shape by means of anchor points.
See **Clipping path**

PC (personal computer)
A general term applied to any desktop computer. Often used to distinguish **IBM™ compatible** computers from **Apple Macintosh™** computers.

PCD
See **PhotoCD**

PCM (pulse code modulation)
A technique for digitizing sound into binary code by sampling techniques.

PCMCIA card (Personal Computer Memory Card International Association)
An association formed in 1989 to establish worldwide standards for credit-card sized memory devices. Various types are available including Types I, II and III. These removable cards can contain memory chips, hard discs, networking capabilities and modems. They are being used increasingly in digital cameras for image storage.

PCX
The native file format for PC Paintbrush™, a paint program used with **DOS**.

PDF
See **Portable document format**

PDL (page description language)
A set of instructions which relays information to the output device relating to the placement of images, text and other data, e.g., **PostScript™**.

PEL
An old, now little used alternative term for **pixel**.

Peltier element
See **Dark current**

Pentium
The name given to the range of microprocessors from Intel™ following the 486 series.

Peripheral
A device such as a **scanner** or **CD ROM** drive attached to a computer.

112

Phase change ink jet

This type of **ink jet printer** uses solid ink sticks rather than liquid reservoirs. It is a two-phase process. Firstly, the solid ink is melted, then sprayed onto the paper in the appropriate pattern. The ink then re-solidifies as soon as it hits the paper. It gives excellent quality on a wide variety of paper weights, surfaces and sizes up to A3.

Phosphor

The chemical substance on the screen of a television, or computer monitor, which glows when struck by an electron beam. In colour display systems there are three phosphors, one for each of the red, green and blue primary colours, to provide a colour **gamut** by additive synthesis.

PhotoCD

A system developed by Kodak™ for storing digital, high resolution images originally recorded on silver-based film, by transfer to compact disc. The film images are scanned using a **photo-imaging workstation (PIW)**, and several different versions of each are made. In the case of the Master disc (for 35 mm only) five versions are made (*see* **base resolution**). PhotoCD images can be viewed on analogue television systems, using a dedicated PhotoCD player, or accessed through the CD ROM drive on a computer system. Several different PhotoCD formats are available, capable of storing high resolution images, multimedia, pre-press and database files. They are summarized in the table overleaf.

Photodiode

A light sensitive photocell which generates a voltage in proportion to the amount of light falling upon it.

PhotoGrade

A technology developed by **Apple™** to improve the quality of **halftone** images produced by **laser** printers.

113

Format	Input source	Disk capacity	Resolution
PhotoCD Master	35mm only	max 100*	16Base Image Pac
Pro PhotoCD Master	35mm– 5●◆4"	30–100*	16Base to 64 Base
Print PhotoCD	film, artwork or digital file	max 100*	16Base Image Pac and standard CMYK files plus any digital file
PhotoCD Portfolio II	film, artwork or digital file	max 700* images or up to one hour of sound, or combination of both	16Base, plus any digital file
PhotoCD Catalog	database for digital images from PhotoCD or scanner	max 6 000*	low resolution

* exact amount varies according to size and type of original

Photographic clip-art
See **Royalty free images**

Photography
Literally, from the Greek, *painting with light*. Generally, the term refers to the recording of images onto a light sensitive silver halide emulsion coated onto a glass, plastic or paper base, which may then be processed to produce a visible image.

Photomechanical reproduction
The reproduction of images, text and graphics using a

114

combination of photographic and mechanical printing processes.

Photomultiplier tube (PMT)
A device used in **high end drum scanners**. It consists of an evacuated glass tube containing a light sensor (photocathode). Electrons released from the photo-cathode are multiplied by a process known as secondary emission. An analogue electrical signal is generated, in proportion to the light received. This is converted by an **ADC** into a digital data stream.

Photo-realistic
A video display which shows photographic quality images. When applied to computer monitors, it generally refers to 24 bit displays.

Photosensitive
Property of a material which undergoes a physical change due to the action of radiation, particularly light. The term encompasses fabric dyes, which may fade, photographic materials, and electronic sensing devices such as video tubes and **CCD** sensors.

Photosensor
See **CCD**

Photoshop™
An image processing program y developed by **Adobe**, which has become the *de facto* standard for desk top image processing.
See also **Native file format**

Photosite
Alternative term for a **picture element** or **pixel** on a

115

CCD photosensor.
See **Pixel**

PIC
A standard image file format used for animation files.

Pick-up device
A camera tube or solid state image-sensor that converts incident light on its photo-sensitive surface into a corresponding electrical analogue signal. Solid state devices use a matrix of very small photo-sensitive cells called a **CCD**.

PICT
The name given to **Apple**'s internal binary format for a black and white image in vector or bitmap image. A PICT image can be directly displayed on a Macintosh screen, or printed. The resolution is relatively low, and the images cannot be scaled to another size without loss of detail.

PICT 2
A variant of the PICT format, used for describing 32-bit colour data files.

Pictrography™
A system introduced by Fuji™ that uses laser technology to write an image onto a chemically impregnated donor sheet inside the machine. Red, green and blue lasers are used to form the image on the surface of the donor material which is then brought into contact with the transfer paper surface and heated. The activating element in the system is a small amount of distilled water which is removed by the heating process. The used donor sheet remains inside the printer and as the process uses a silver halide based system, the residual silver can be recovered from the donor sheets.

Picture element
See **Pixel**

Pit
The name for a minute indentation in the surface of a compact disc.

PIW (photo imaging workstation)
A unit sold by Kodak for the production of **PhotoCD**s. It consists of a **scanner**, computer and a **thermal dye sublimation printer** for the production of **index prints**.

Pixel
The term derived from **picture element**, usually taken to mean the smallest area capable of resolving image detail in a pick-up device such as a **CCD array**. An **area array CCD** in a digital camera may have 640 pixels horizontally by 480 vertically, giving a total of 307 200 pixels. The image from the CCD in a camcorder is in the form of pixels, but is converted to a continuous video signal. In most systems in use today, pixels are square in shape, but occasionally, pixels may be rectangular, round, or even triangular. If an image with rectangular pixels is transferred into a program using square pixels, then the aspect ratios of the image will be different, and a correction factor must be applied. For example, if the rectangular pixels have an aspect ratio of 2:1, the image will need to be stretched horizontally by 200 per cent to retain the proportions of the original image. Systems that produce rectangular pixels include the PVC™ of IBM, with **TrueVision™** or Vista™ video boards that broadcast **NTSC** and **PAL** video. Amiga™ systems produce pixels with an aspect ratio of 1.45:1, whilst **TARGA** files for the PC have an aspect ratio of 1:0.97.

Pixel-based editing
A feature of image processing programs which use

bitmaps for the display and processing of images. Any changes made to the image is done by changing the values of individual pixels within the bitmap.

Pixel cloning
See **Cloning**

Pixellation
A subjective impairment of an image in which the individual pixels are large enough to become visible.

Pixel skipping
A means of reducing image resolution by deleting pixels.

Plasma display
A type of television display that uses a gas which glows when an electrical current passes through it.

Platform
The type of computer system, e.g., **Apple Macintosh™** or **IBM PC** Compatible.

Plug and play
A facility with computer operating systems of being able to plug in a new peripheral device, or circuit board, and then not having to go through a configuration routine.

Plug-in
A small piece of software often supplied with scanners and other peripherals, allowing the user to access and control those devices through an image processing software package such as **Adobe Photoshop™**. Many third party manufacturers market extra filters and other special effects (such as **Kai's Power Tools™** and **Convolver™**) as plug-ins to programs like Photoshop™.

118

When installed, the plug-in becomes an item on one of the program's menus (*see* **driver**). Often referred to as **Export** and **Acquire** modules, depending on whether the device is inputting to the program, or the program is outputting to the device.

PMS (Pantone matching system™)
An industry standard system for defining the colour composition of mixed inks. PMS gives the formula for mixing ink colours. Particular colours are given a number, e.g., PMS 285–1 is a deep green colour.

PMT
See **Photo multiplier tube**

PNG (portable network graphics)
A relatively new file format which allows for the progressive rendering of an image, together with other information such as colour management data.

Point processing
An image processing operation which operates on single **pixels**, e.g., pixel counting.

Pointing device
A device attached to a computer which controls the movement of a cursor on the screen, e.g., a mouse, stylus or trackball.

POP
1 **Point of presence**
 The location of an **Internet** service provider. It is important when choosing a provider to choose one that is only a local telephone call away
2 **Post office protocol**

Refers to the way **e-mail** software such as **Eudora**™ gets mail from the mail server.

Port
The socket into which various devices such as scanners, printers, modems and CD drives are plugged to connect them to a computer. There are various types including **serial**, **parallel** and **SCSI**.

Portable document format (PDF)
This is a **PostScript**™ based file format developed by Adobe for its **Acrobat**™ software, which preserves the text, graphics and formatting of the original document. Thus any document in PDF format can be viewed in its original form, using Acrobat Reader software on any platform. Acrobat Writer™ is required to produce the format. It is used, for example, to produce scientific journals for distribution via the **Internet**, where charts and graphs are an essential part of the content.

Portable network graphics
See **PNG**

Posterization
Traditionally, a photographic printing method of reducing a continuous tone monochrome or colour image to a predetermined small number of tones, each of which is a uniform tone or colour value. Typical posterizations will have between three to five tones. Image processing programs usually have a facility for producing such posterized images. Stretching the tones of a digital image to excess may cause a posterized (or **banding**) effect.

Post processing
The process of applying all the changes and alterations

made to an image in programs such as **Live Picture**™ at the end of the manipulation stage.

PostScript™
A **page description language (PDL)** developed by Adobe Systems, and used in laser printers to simulate the operations of printing, including placing and sizing text, drawing and painting, graphics, and preparing halftones from digitized greyscale images. It consists of a set of software commands and protocols that form images on output devices when translated through a **raster image processor (RIP)**. It is 'device independent', allowing output devices of differing types and manufacturer to print the same file in the same way. It has become a standard way of 'driving' high quality printers. The original version was called Level 1. The later Level 2 incorporated definitions for **colour space**, and for colour data compression.

PowerPC
The latest generation of micro-processors being used in **Apple Macintosh**™ computers, developed as part of an alliance between Apple, IBM and Motorola. They are based on **RISC** technology.

PPD (PostScript printer description file)
A file specifying the characteristics of an output device.

PPI (pixels per inch)
A standard unit of measurement for the **spatial resolution** of scanned images.

Primary colours
The three primary colours of white light are red, green and blue.

Printer buffer
See **Buffer**

Process colours
Cyan, magenta, yellow and black.

Process inks
The four specific inks used in the four colour printing process, namely cyan, magenta, yellow and black.

Profile
The characteristics (usually of colour and contrast) of a device such as a printer or scanner, or of film. Used by **colour management systems** to ensure colour consistency throughout the printing process.

Program
The application used by computers.

Progressive JPEG
See **JPEG**

Prompt
A symbol or character on the computer monitor indicating that the computer is waiting for an instruction.

Proof
A visual representation of how an image will finally appear when printed. Several proofing devices are available such as **Cromalin™**, **Approval™** and **Match-print™**.

Pro-PhotoCD
A **PhotoCD** format which contains **Image Pac** files from

122

64Base to **Base/16**, which range in size from 72 Mb to 72 Kb. It is used for film originals up to 5×4 inches in size. The information for the 64Base image is held in a special file, the **Image Pac Extension (IPE)**.

Protocol
A set of defined rules for the exchange of digital data which allows communication between computer systems.

Proxy
A low resolution version of an image file which may be processed. When the various operations have been completed, they can then be applied to a higher resolution version.

Pseudo-colouring
The process of either adding colour to, or modifying the colours of an image. In the case of greyscale images, particular grey tones can be assigned specific colours.

Public domain
Software which is free to use.

Pull down/pop up
A menu which appears when the main menu title is clicked at the top of the screen.

Qq

'Q' factor (quality factor, sometimes called 'halftoning factor')

A multiplication factor used to calculate the scanning resolution necessary for optimum output quality. The resolution of the original digital file is defined in pixels per inch, (or dots per inch), whilst half tone printers conventionally use lines per inch. The Q factor can be used to determine which ratio of pixels to lines (dpi:lpi) gives the optimum result, for example:

less than 1:1 (dpi<lpi)

If less than one pixel per line is used, the image will display **pixellation**, and the software will have to **interpolate** between pixels to generate information. The user has no control over this process and the end result is dependent on the software's interpolation capabilities. If a smaller file has to be used, the best compromise is to interpolate the file size in an imaging software package allowing the user to choose the interpolation method (**bicubic**, **nearest neighbour**, etc.) and examine the result prior to printing.

1:1 (dpi = lpi)

If the number of pixels matches the number of lines, the resulting image can display artifacts such as **aliasing**, and colour artifacts introduced by the screening angles used to avoid **moiré** patterns.

Given therefore that the requirement in the conversion from dpi to lpi requires an **oversampling**,

the question arises as to how much should that oversample be?

1.25-2.0:1 (dpi > lpi)

The standard 'rule of thumb' used in the printing industry is to supply *twice as many dots (or pixels) as lines*. This figure is worth testing however, with ratios between 1.25:1, and 2:1, and it may well be found that there is no perceptible difference between them. Using smaller file sizes will lead to a saving in both time and material cost.

2-2.5: 1 (dpi > lpi)

The extra information supplied at ratios of 2:1 and greater gives no perceptible addition in quality. In ratios of over 2.5:1 the information is ignored by the **PostScript RIP** conversion process entirely.

By experimentation, a 'Q factor' can be found within the region of 1.25–2:1. The following guidelines can be used as a basis for further experimentation:

- Values of 'Q' from 1.25 to 2.0 work well for halftone dot images.
- Choose a 'Q' value of 2 if screen ruling is 133 lpi and below.
- Choose a 'Q' value of 1.5 if screen ruling is above 133 lpi.
- Values of 'Q' over 2 are wasteful, just leading to large file sizes.

With the advent of new screening processes such as **stochastic (FM – frequency modulated) screening**, lower pixel resolutions still are possible, with the Q factor falling as low as 1:1.

Quadtone
See **Duotone**

Quantizing
The process of converting brightness into discrete values.

QuarkXpress™
An industry standard **desktop publishing** program for **Apple Macintosh™** and **IBM™** PC compatible computers.

Quartertone
Tonal values roughly in the region of 25 per cent.

Quickdraw™
Part of the **Apple Macintosh™ operating system** which handles the screen display and other graphical functions.

QuickMask
A specific function found in **Adobe Photoshop™**. A selected area of the image can be instantly converted into 'QuickMask mode', which can be saved as a separate channel.

QuickTime™
An extension to the Macintosh™ **operating system** developed by **Apple** for storing video and animation. It incorporates video compression technology.

Rr

RAID (redundant array of independent discs)
A high end storage system using a number of connected hard drives. The basic idea is to use two or more drives which are combined into a single logical drive. Data is written onto the drives in sequence. Various levels of RAID exist, and in its most sophisticated form, the data is error checked as it is written. The system offers very fast writing and retrieval. In some cases, one of the drives can fail, yet be replaced without loss of data, and without shutting down the system. Several major picture libraries use the system for archival storage of their images.

RAM (random access memory)
Temporary memory created and used only when the computer is switched on. The size of images which can be opened is dependent on how much RAM is installed in the computer.

Random access
The ability to access stored information directly, rather than having to go through all the previously stored data.

Raster
A series of scanning lines in a pattern which provides uniform coverage of a subject or image area. The number and length of the lines are related to spatial resolution.

127

Raster graphic
A graphic image, created by **scanners**, **digital cameras** or **paint** programs, whose individual components are individual **pixels**.

Raster image processor
See **RIP**

Rasterize
The conversion of mathematically defined points in **object oriented** drawing packages, or the data contained in a **FITS** file in **Live Picture™**, into pixels for output to a printing device.

Raster unit
In electronic imaging, the distance between the mid points of two adjacent pixels.

RAW
An image file format containing plain binary data with no extraneous information. It does not compress images, and does not specify bit depth or image size.

Read
In computing, to access data from a disc, tape or memory, and display it on a screen.

Read only memory (ROM)
Memory which can only be read from and not written to. It resides in special chips on the motherboard of the computer, and is where the **firmware** is kept.

Real-time
Refers to computer operations which occur immediately.

128

Receptor
General term used for a substance on which radiation
can fall, and which responds to that radiation, e.g.,
photoreceptors, photocell and the retina of the eye.

Recomposition
The term used to describe the generation of the higher
resolution images within a **PhotoCD Image Pac**.

Red Book
This **Colour Book standard** defines the standards for
audio CDs. A **CD-DA** can hold up to 99 tracks, with a
theoretical maximum playing time of 72 minutes.
 The standard specifies an **error detection code
(EDC)** and an **error correction code (ECC)**, to interpolate
information if a disc has been scratched or scuffed.
See also **Colour Book standards**

Reflective copy
Photographic print or other media viewed by reflected
light.

Refresh rate
The time taken for the computer monitor to update the
information on the screen.

Register marks
Small marks printed alongside artwork and images,
which are superimposed during printing, to ensure that
the printing plates are in register.

Registration
1 The superimposition of image separations so that
 they overlay precisely.

2 To agree to abide by the conditions of the licensing agreement supplied with a piece of software. Only registered users of software will be entitled to upgrades.

Rel (recorder elements per inch)
The minimum distance between two recorded points in an **imagesetter**.

Remote sensing
The capturing of an image from a remote subject – usually applied to satellite imaging.

Render
The action of applying a surface texture to a two or three dimensional **wire-frame** surface or shape drawn in a computer graphics program, to produce a more realistic effect.

Replication
A form of image re-sampling where the exact colours of neighbouring pixels are copied. This should only be used when doubling or quadrupling resolution, i.e. 200, 400, 800 per cent, etc.

Reproduction gamma
The relative contrast of the midtones of a printed reproduction of an image compared to the original. Adjusting the gamma, by using the **curves** control allows the user to modify the contrast of the midtones without affecting the shadow or highlight tones.

Reproduction rights
The right, arising from ownership of copyright of an image, that allows the making of copies in any medium.

The copyright owner may license others to reproduce the image, usually for a specific purpose, size and market.

Res
A metric term used in place of ppi to define image resolution. Res 12 equals 12 pixels per millimetre (305 ppi).

Resampling
Changing the resolution of an image, either by discarding unwanted pixels, or by interpolating new ones.

Re-sizing
Changing the size of an image without altering the resolution. Increasing the size will lead to a decrease in image quality.

Resolution, brightness
This refers to the number of bits of stored information per pixel. A pixel with 1 bit of information has only two possible values, white or black. A pixel with a **bit depth** of 8, has a possible 2^8, or 256 values, whilst a pixel with a bit depth of 24 has a possible 2^{24}, or over 16 million possible values.

Resolution, spatial
The ability of an image recording system to record and reproduce fine detail. In digital imaging, the resolution of the final image is dependent upon the resolution of the image capture device (camera, scanner, etc.), any change made during image processing by computer, and the resolution of the output device. The term image resolution refers to the number of pixels within an image, and is measured in pixels per inch. An image

recorded with a Kodak DCS 460™ camera, for example, has 3072×2048 pixels – 6 291 456 pixels in total. Because the number of pixels within an image is fixed, increasing or decreasing the image size (**re-sizing**) will alter the resolution. Increasing the size will cause a decrease in the resolution. Image processing programs like **Adobe Photoshop™** have the facility to both re-size and re-sample the image.

When looking at the resolution of imaging devices, in particular scanners, it is important to distinguish between **optical resolution**, i.e. the actual number of picture elements on the CCD, and higher resolution created by the process of **interpolation**. A scanner may be advertised as having a resolution of 1200 dpi, where in actual fact it has an optical resolution of 600 dpi, interpolated to 1200 dpi by the scanning software.

Video resolution is given as lines per picture height, e.g., 625 lines. **CRT** resolutions are usually given as number of pixels per scan line, and the number of scan lines, e.g., 640×480 (**NTSC**), 768×512 (**PAL**). Printer resolutions are usually given as dots per inch, e.g., 300 dpi.

Resolving power
The ability of an imaging system to record fine detail, usually measured by its ability to maintain separation between close subject elements such as fine lines (usually quoted as **line pairs per millimetre**).

Resource fork
The area of an **Apple Macintosh™** application file that comprises information relating to menus, fonts, file formats and icons.

RGB (red, green, blue)
The three primary colours used in monitor displays.

RIFF

1 **Raster image file format**
An image file format for greyscale images. Has the chief advantage of offering significant disc space savings by using data compression techniques. Letraset's™ proprietary alternative to **TIFF** that stores up to 32 bit information, but is only used with Letraset™ programs such as Colour Studio™.

2 **Resource interchange file format**
A file format for multimedia which allows graphics, sound, animation and other data to be stored in a common, cross-platform form.

RIP (raster image processor)
A device which converts a page description language (**PDL**) such as **Postscript™** into the raster form necessary for output by an **imagesetter**, **film recorder** or **laser printer**.

RISC (reduced instruction set computing)
A modern microprocessor chip which works faster than previous versions by processing fewer instructions (found, for example, in the **Apple Power PC™** computers).

RLE (run length encoding)
See **Huffman encoding**

ROM (read only memory)
A memory unit in which the data are stored permanently. The information is read out non-destructively, and no information can be written into memory.

Royalty free images
Collections of images which are sold commercially, and which can then be used by the purchaser for a wide

133

variety of publication purposes without further payment of royalties. The copyright of the images remains with the original owner. Sometimes referred to as **photographic clip-art**.

RS 232
The designation by the Electronics Industries Association for the industry 'standard' for **serial ports** in computers. The 'standard' is not completely uniform however, and several different connectors are used.

Rubber stamp
See **Cloning tool**

RUN
In some computer systems, such as DOS, the instruction given to start the execution of a programmed task.

Run length encoding (RLE)
See **Huffman encoding**

Ss

Samples per inch (spi)
Same as pixels per inch.

Sampling
The process of converting an **analogue** value varying
continuously with time into discrete values.

Saturation
The strength or purity of a colour.
See **HSB**

Save
To write a new version of a file over the old version.

Save as . . .
To save a new version of a file, with the opportunity of
giving it a new filename.

Scale of reproduction
The degree of enlargement or reduction of a reproduced
image. Usually quoted as a percentage.

Scaling
The process of enlarging or reducing the size of an image
for reproduction.

Scan back
A **linear** (or **tri-linear**) **array CCD** placed in the focal
plane of a camera (usually a medium or large format i.e.

120 or 5×4 inch format), to scan the image projected by a lens, and record the image in terms of digital data rather than in analogue form on film.
See **Digital camera**

Scanner
Any device which converts artwork, photographs or text into digital data. There are several types, classified according to the type of original to be scanned, and their method of operation. They are: **flatbed**, **film**, **drum** and **hand**.

Scanning
1 The horizontal and vertical movement of the electron beam in a **cathode ray tube (CRT)**.
2 The process of converting analogue image data into digital data by means of a scanner.

Scanning line
A line scanned by an electron beam, to gather the information necessary to reproduce the image. The more lines that are used, the better the reproduction.

Scan resolution
The resolution at which an original is scanned. Usually quoted in **pixels per inch** (ppi), **samples per inch** (spi), or **Res** (pixels per millimetre).

Scitex CT (continuous tone)
An image file format used to export files that can be read directly by Scitex™ work stations.

Scratch disc
A reserved area of a hard disc used for temporarily storing a copy of an image being processed.

Screen
1 The part of the computer monitor or television on which data is displayed.
2 A **halftone** pattern used by printers to enable images to be printed by **photomechanical reproduction**.

Screen angle
The term referring to the angle at which two or more halftone screens are positioned relative to the image to minimize undesirable dot patterns or **moiré** effects.

Screen dump
Where an entire screen display, including menus, tools, background, etc., is printed, or saved as a file. The illustrations of the histograms in this book, for example, are 'screen dumps' from **Adobe Photoshop™**.

Screen frequency (screen ruling)
The resolution of a halftone screen, in lines (of dots) per inch (lpi). Typical values for different paper types used in the print industry are as follows:

Newsprint	80 – 100 lpi
Books	133 lpi
Magazines	150 – 175 lpi
Quality reports	200 – 300 lpi

Scrolling
To move the contents of a **window** vertically or horizontally so that the part of a document or image hidden by the edges of the window can be viewed.

SCSI (small computer systems interface)
This type of **port** permits high speed communication between the computer and peripheral device, such as

a scanner, external hard disc, CD ROM drive or even digital camera.

Up to six extra SCSI devices can be connected to a computer. They are linked, or 'daisy-chained' together, with each device being assigned a specific identity number. This 'I.D. no.' can be set on each device using switches on the back. By convention, the internal hard disc of the CPU is I.D no. 0, and the computer itself is no. 7, which means that six other devices can be connected. SCSI is a form of **bus** – a common pathway for the relaying of data, shared by several devices. A terminator (terminating resistor) must be used at the start and end of the chain to identify the limits of the bus and prevent signals reflecting back on the bus after reaching the last device. The SCSI bus on a Macintosh Quadra™ computer, for example, can send 5 million characters (5 Mb) per second. It does this by sending the information in the form of 8 bits in parallel mode. SCSI 2 is a wider pathway, enabling 32 bit data transfer. SCSI accelerator cards are available.

Search engine
See **WWW**

SECAM (sequential couleur à mémoire)
The colour television standard used in France and most Eastern European countries. Sequential lines are scanned instead of alternate lines as in **PAL**.

Seek time
The time taken to access data from a disc (same as **access time**).

Selection
A portion of an image that has been chosen or designated for processing. When a selection is made in an image processing program, the selected area is often delineated by an animated line often referred to as '**marching ants**'.

Semiconductor
A crystalline material, the resistivity of which is between that of an insulator and a conductor. Semiconductors are used in the manufacture of **integrated circuits** including **CCD**s.

Separation
The process of producing the four colour data files (cyan, magenta, yellow and black, or CMYK) comprising the necessary information for a colour image to be printed.

Serial port
A multipurpose **port** for connecting mice, modems and other devices to the computer. The basic principle of the serial port is to have one line to send data, another to receive data, and several others to regulate the flow of that data. The data is sent in series, i.e. one bit at a time. This is somewhat inefficient, but no problem for communicating with a device like a mouse, which doesn't require speed, and for modems connected to standard telephone lines which can only handle one signal at a time.
See **RS232**

Server
A dedicated computer or computer program which

provides a specific service to 'client' software running on computers connected to it.

Session
A single continuous recording of data to a **CD ROM**.
See **Multi-session**

SGML (standard generalized mark-up language)
A set of standards used for 'tagging' the various elements of an electronic document, in order to facilitate its production in various media.

Shadow mask
A perforated metal plate or mask physically separated from the mosaic of red, green and blue phosphor dots on the inner surface of a **CRT**. It directs and restricts the passage of the three electron beams passing through it, so that they strike only their corresponding colour emitting phosphor.

Shareware
Software which is freely available, but which must be paid for if the user decides to continue using it.

Sharpness
A subjective term relating to the perceived quality of an image, usually associated with the abruptness of change of tone at the edge of an object or tonal area.

Shift register
A series of electronic circuits capable of storing and transmitting the electrical charge out of the **photosites** so that they can be read sequentially by an **ADC**. They are used in **CCD**s to store the electrical charge created by the light falling on the picture elements.

Signal
A general term for any input into an imaging or other system that causes an appropriate action with respect to output.

Signal to noise ratio (S/N or SNR)
The relationship between the required electrical **signal** to the unwanted signals caused by interference [usually measured in **decibels** (db.)]. The S/N figure should be as high as possible for a given system.

SIMM (single in-line memory module)
A small circuit board containing solid state memory chips used to increase the RAM of a computer.

Smearing
An artefact typical of some older **CCD** arrays when a particular pixel or group of pixels is over-exposed due to imaging a particularly bright object. Smearing appears as a vertical streak above and below the image of the object or light source.

Smoothing filter
A filter which blurs (softens) a selected area. It can be used to reduce noise in an image.

SNAP (specifications for newspaper advertising publications)
A similar set of specifications as **SWOP**, aimed at achieving consistency of advertising in a variety of printed publications on newsprint.

SNR
See **Signal to noise ratio**

Sobel operators
A group of **filters** used in image processing for enhancing edge detail.

Soft display
Refers to the display of transient images on **television** screens or **monitors**, as opposed to **hard copy** prints.

Software
The range of programs run by a computer.

Solarization
With photographic emulsions, the effect of solarization occurs with gross overexposure, and results in a reduction in density with increasing exposure. There may be a reversal of some of the tones, leading to an image with a mixture of negative and positive tones. Most image processing programs like **Adobe Photoshop**™ have a 'solarize' filter. The effect can also be achieved manually by manipulation of the tone **curve**.

Solid state circuit
Any electronic circuit where the various elements are composed of semiconductor devices such as transistors rather than vacuum tubes.

SPARC (Scalable Process Advanced RISC Computer, or Scalable Performance ARChitecture)
A 32-bit RISC based computer developed by Sun Microsystems™.

Spatial frequency
In digital imaging, brightness value. The change of brightness value from pixel to pixel is referred to as

142

spatial frequency change. If closely spaced pixels change brightness values rapidly, this is described as high frequency information. Low frequency information is minimally changing pixel brightness.

Spatial resolution
See **Resolution, spatial**

Speckling
Another term for the **noise** which appears as isolated light toned pixels in dark image areas.

Spectral
Relating to the spectrum, in particular the variation in response or output with wavelength.

Spectral energy distribution
The energy output of a source related to the wavelength of the emitted radiation. Light sources have spectral energy distribution curves from which their performance and suitability can be ascertained.

Spectrum
See **Electromagnetic spectrum**

Specular highlight
A part of the image showing a bright source of light, such as the reflection in a highly reflective metal surface, or a streetlamp at night.

Spot
The smallest diameter of a light beam that a **scanner**, **filmwriter** or **imagesetter** can use for exposure. The smaller the spot size, the higher the resolution of the device.

Spot colour
The use of a non-process colour, usually a fifth ink in the printing process. Company logos often use specific spot colours for purposes such as corporate identity.

Staircasing
See **Aliasing**

Step wedge
See **Grey scale**

Still video (SV)
An electronic still camera employing a solid state pick up device (**CCD**) in the focal plane, and recording the analogue signal on a SV floppy (**SVF**) disc (or memory card) for subsequent playback. The discs can record 50 low resolution *field* images, or 25 high resolution *frame* images together with a limited amount of audio. The discs can be erased and re-recorded.

Stochastic screening
An alternative to conventional screening that separates an image into very fine, randomly placed dots as opposed to a grid of geometrically aligned halftone cells. It is similar in concept to **mezzotint**, but whereas in a mezzotint the dots are meant to be large enough to be visible, with stochastic screening the dots must be small enough to be invisible.

Stylus
The name given to a pen shaped pointing device used on a graphics, or **digitizing tablet** to perform the function of moving the cursor on the screen. Some styli

144

are 'pressure sensitive', so that the more pressure is used, the more paint is applied to an image, and some can be reversed to act as an eraser.

Sublimation
The process by which a solid becomes a gas without first passing through a liquid phase.

Subtractive primary colours
Cyan, magenta and yellow are the complementary colours to red, green and blue respectively.

Supersampling
Many **scanners** and other devices such as **digital cameras** can differentiate more than 256 tonal levels (8 bit) for each RGB colour. Values of 10, 12, 14 or 16 bits are capable by some devices.

SV
See **Still video**

SVF (still video floppy)
A 50 mm diameter magnetic disc used in electronic **still video** cameras to store analogue images, and in some cases, sound data as well.

SVGA (super video graphics array)
A **CRT** resolution of 800×600 pixels at 256 colours minimum. At this resolution, the CRT is **non-interlaced**, and has a high refresh rate to limit **flickering**.

SWOP (specifications for web offset publications)
Technical guidelines produced by SWOP Inc. specifically for printers of magazines, but also used extensively

by commercial printers. They relate to such things as **dot gain**, inking requirements, and recommended shadow areas.

Syquest™

Proprietary name given to a range of removable hard discs, ranging in capacity from 44 to 200 Mb.

Tt

TA
See **Thermo-autochrome**™

TARGA™
See **TGA**

TCP/IP (Transmission control protocol/Internet protocol)
A set of protocols that define the **Internet**, i.e. the exchange of data between connected computers. It was originally designed for Unix™ systems, but is now available for most types of computer platform. A computer must have TCP/IP software to link to the Internet.

Television
The system of transmitting or broadcasting electrical signals for the reproduction of images (and sound) at a distance.

Terabyte (Tb)
One trillion bytes.

Terminal
A computer attached to a network. A 'dumb terminal' is a machine which does not have its own software or hard disc for storage.

TGA (Targa file format)
A file format used for saving and transferring 24-bit files on PCs.

Thermal printing
A range of printing devices which utilize heated rollers to transfer the printing medium onto the paper. Examples are **thermal wax**, **thermal dye sublimation** and **thermo autochrome**.

Thermal dye sublimation printer
This method of printing uses a system of transferring dyes from magenta, yellow, cyan and, in some machines, black ribbons onto a paper surface. A heating element the width of the paper vaporizes (by **sublimation**) the dye on the donor ribbon surface which is then absorbed into the surface of the paper. The image is generated by applying three or four passes of the donor ribbons to a single sheet of paper. The registration of the paper during each pass is crucial to the quality of the final image. As the dyes are transparent each pixel on the page can represent any colour by varying the amount of the three (or four) colours. The action of the dye in being absorbed into the paper also means that the individual pixels join together to form a seamless area of colour similar to a true photographic print. Many models have an ultraviolet absorbing filter layer which is applied to the paper surface to reduce fading.

Thermal wax transfer printer
This printing method works by heating coloured wax sheets and melting it onto a paper surface. The wax is transferred or 'ironed' onto the paper by thousands of individually controlled heating elements

each heated to 70°–80° C which will melt a tiny pinpoint of colour. Colour images are created by a four pass system using cyan, magenta, yellow and black. These printers tend to be relatively inexpensive.

Thermo-autochrome™ (TA)
A **photo-realistic** printing system developed by Fuji, which uses special paper consisting of three dye layers (cyan, magenta and yellow) plus a heat resistant layer coated onto the surface. Within each layer, 1μm diameter microcapsules are embedded, which produce a dye in proportion to the amount of heat received from the printer's thermal heads. The effective resolution is 300 dpi.

Three quartertone
The tones in between the highlight and midtone, or midtone and shadow.

Threshold
A particular brightness value which determines a transition. For example, in one instance, all pixel values above the threshold level may be assigned black, and all pixels below the threshold level may become white, thus creating a **binary** image.

Throughput
The amount of material put through a particular process or machine.

Thumbnail
A very low resolution version of an image used for sorting and finding images.
See **Index print**

TIFF (tagged image file format)

This is perhaps the most widely used of the image file formats available today for bitmapped images, and was designed in the late 1980s by Microsoft™ and Aldus™ to try to standardize on the growing number of images being produced from scanners, etc., and to allow transference of images from one **platform** to another. There are several versions of TIFF in existence, though these usually cause no problems when using the format. When saving images in TIFF form, the user can choose the option of PC or Macintosh™ platform, and also whether to employ '**LZW**' compression or not. This is a '**lossless**' **compression** system, i.e. no data is lost during the compression process. As Table 1 shows (*see* **file size**), the file size is reduced by about 50 per cent, though this will vary according to the content of the image.

Both TIFF and **EPS files** are made up of two parts. Firstly, a low resolution version of the image (known as a **PICT** preview) to be used 'for position only' (**FPO**) in a page layout. TIFF files do not become embedded into documents (unlike PICT files). Instead they produce a small 72 dpi version of themselves for positioning. This is 'tagged' to the actual image data, which replaces the low resolution FPO version during printing. It is therefore essential that TIFF files must be sent along with the page layout for printing. When the TIFF file is placed in a page layout, the computer can always access it automatically, no matter where it is, provided that it is not moved out of the location it was in when it was placed into the page. If it is moved, the computer will not be able to find it. It is thus good practice to keep TIFF files in the same folder as the page layout in which it is placed, and with the information relating to the colour and resolution of the image necessary to output

150

it. It is however in RGB format, and will need to be separated into CMYK for reproduction.

TIFF/EP (tagged image file format for electronic photography)
A version of TIFF used by Kodak digital cameras to store non-image data such as date, time and exposure details, with many different types of image data.

Tonal range
The range of tonal densities or values within an image.

Tone reproduction
The relationship between the tonal range of the original subject or image, and the final reproduction.

Tool
A feature of most graphics programs that allows the user to convert the **cursor** into a specific device, which then performs certain tasks, such as drawing, painting, cloning, selecting or adding text.

Toolbox
A visual palette of **tools** available within image processing and drawing programs (Figure 13).

Touch screen
A computer **monitor** which is touch sensitive, and allows the viewer to access information by touching certain designated areas of the screen. They are used particularly in museums, art galleries and the like.

Track
A band of data on a recording medium.

Figure 13 The 'toolbox' in Photoshop 4, showing a range of selection, cropping, drawing, painting and enhancement tools.

Trackball
A large rotatable ball which replaces a mouse for moving a cursor and other **tools** around on the screen.

Transfer rate
The rate at which data is transferred, usually from one disc drive to another.

Transfer register
See **Shift register**

Transparency
1 Silver halide photographic material which, when developed by a reversal process yields a positive image on a transparent base.
2 A transparent output from a digital printer such as a thermal dye sublimation printer, particularly in the form of cels for use in overhead projectors.

Trapping
The slight, deliberate, overlap of two colours to eliminate gaps that may occur in slight mis-registration of printing plates.
See **Colour trapping**

Triad
An arrangement of three phosphor dots (red, green and blue) which are excited by the electron beams in a colour television system to emit coloured light.

Trichromatic
Three colour.

Trilinear array CCD
See **CCD**

Trinitron™
See **CRT**

Tritone
See **Duotone**

True colour
A term used to describe the **photo-realistic** quality given by 24-bit computer displays.

TrueType™
A font format created by the Microsoft™ and **Apple™** Corporations.

True Vision™
Manufacturer of frame-grabber boards under the **TARGA™** label.

Trumatch™
A colour matching system similar to **PMS**. It is not widely used.

Tube
See **CRT**

TWAIN (technology without an interesting name)
A cross platform interface for acquiring images with **scanners** and **frame grabbers**.

Tweening (in-betweening)
In computer animation, where the operator describes the first frame of a sequence, and another later on in the sequence, and the computer generates the frames in-be*tween*.

Uu

UCA (under colour addition)
The practice of adding cyan, magenta and yellow to areas that are predominantly black, in order to achieve a richer and darker colour.

UCR (under colour removal)
A process for improving the quality of colour reproduction by changing the relative balance of the inks applied. The amount of yellow, magenta and cyan inks is decreased, whilst the amount of black is increased.

Ultraviolet
Electromagnetic radiation between approximately 100–400 nanometres. Silver based film emulsions are sensitive to the longer ultraviolet wavelengths. **CCD** sensors are also inherently sensitive to ultraviolet, though most chips are coated with a filter to absorb it. Some manufacturers supply the chips without the filter for specialist applications. Glass lenses do not transmit ultraviolet well, and if the prime requirement is ultraviolet imaging, it may be necessary to use lenses constructed from materials which transmit large amounts of ultraviolet such as quartz glass.

Undo
A standard command found in most computer programs to revert to the previous version of a saved document. Several imaging programs allow multiple levels of 'undo'.

Unix™

A computer operating system designed specifically for multi-user systems. Servers on the **Internet** invariably use Unix.

Unsharp masking
See **USM**

URL (uniform resource locator)

The standard naming and addressing system on the World Wide Web. For example, the URL of Kodak's digital imaging page is:

http://www.kodak.com/digitalImaging/digitalImaging.shtml

Usenet

A worldwide system of discussion groups.

USM (unsharp masking)

A procedure for increasing the apparent detail in an image, performed either by the input **scanner**, or by the image processing program.

U,V diagram

Type of chromaticity diagram introduced by the **CIE** in 1960, now superseded by u',v'.

u',v' diagram

Uniform chromaticity diagram introduced by the **CIE** in 1976.

Vv

Vector
Mathematical description of a line in space. Vectors are used to describe lines and create objects, etc.

Vector graphics
A type of computer graphics where images (geometric shapes such as curves, arcs and lines) are defined as a series of mathematical formulae rather than a grid of pixels. Also referred to as **object-oriented** graphics.

Vertical scan rate
The rate at which two interlaced **fields** scan to give a complete video **frame**.
See **Flicker**

Vertical smear
An artefact on some CCD designs where a vertical streak is seen above and below a bright object.

VGA (variable-graphics array)
An electronic display standard that defines a resolution of 640×480 pixels with a 16 colour capability, and 320×200 pixels resolution with a 256 colour capability.

Video
An analogue electrical signal generated through the action of light falling upon a photosensor such as a video imaging tube, or **CCD** image sensor.

Video grabber

A form of analogue to digital converter (**ADC**) for digitizing video sequences.

View file
See **Live Picture**™

Viewing conditions

The environment in which artwork or transparencies are evaluated.

Viewing distance

The distance from which an image is viewed. The 'correct' viewing distance for an image, to ensure that the perspective is the same as the camera image is the camera image distance for a contact print, times the magnification. For example, if a negative was made with a 50 mm lens, and a 10× enlargement is made, then the correct viewing distance will be 50 mm×10 = 500 mm.

Virtual memory

A technique for increasing the apparent size of the computer memory available by using additional memory from a hard disc. It is generally a very slow method.

Virus

A computer program deliberately written with the malicious intention of disrupting the normal operation of a computer. Some viruses 'infect' files only, whilst others can destroy application programmes, operating systems, or erase large amounts of data. Virus protection software is available, but by its

very nature, will always be one step behind the author of the virus.

Visually lossless compression
The compression system used by **PhotoCD**, which uses chroma (colour) subsampling, and relies on the limitations of human vision, whereby colour information is not so important as detail. Colour information can therefore be discarded more readily than detail before it is perceived. In the case of PhotoCD the loss is visually lossless.

VRAM (video random access memory)
The memory unit which stores the image being displayed on the computer monitor. The amount of VRAM required for specific bit depths with different sizes of monitor can be calculated from:

VRAM required = Bit depth×(horizontal resolution × vertical resolution)

e.g., A 14 inch monitor, with a resolution of 640×480 pixels, displaying just black or white (1 bit), requires 307 200 bits of information, or 38 400 bytes (bits divided by 8 to give bytes) or 37.5 kilobytes (38 400 divided by 1024 to give kilobytes). To achieve 8 bit colour (256 colours or greys) this monitor will require 37.5×8 = 300 kb. Therefore, a computer with 512 kb of VRAM fitted as standard is capable of displaying 8 bit colour.

To achieve 16 bit (32 000 colours) requires: 37.5×16 = 600 kb.

To achieve 24 bit (16.7 million colours) requires: 37.5×24 = 900 kb.

Ww

WAN (wide area network)
Any network covering an area larger than a single building or site.

Watermark
A logo or name imprinted over an image to act as a deterrent to illegal copying.

Wavelength
The distance on a waveform from the peak of one wave to the corresponding point in an adjacent period. The wavelength of visible light, part of the **electro-magnetic spectrum**, is approximately 400–700 nanometres (nm).

Web
See **W W W**

Website
The place on the Internet where newspapers, magazines, television programmes, large and small companies, and individuals can all have their own collection of material. Websites can vary from one page to several thousand pages, and include hypertext links to other sites, graphics, animations and sound, and 'live' video. Some sites offer the potential for 'downloading' software.

White balance
The relative amounts of red, green and blue light in

a light source. Digital and video cameras can be 'white balanced' i.e. the signal adjusted so that the light reflected from a white or neutral grey surface can be neutralized.

White Book

One of the **Colour Book standards** for CDs. White Book defines the Video CD standard. The standard uses **MPEG** specifications for compressing audio and video files. Full motion video and audio are stored in the **CD ROM/XA** format.
See also **Colour Book standards**

White light

A light source composed of equivalent amounts of red, green and blue wavelengths.

White point

A movable point on an image **histogram** which defines the lightest part of the image. Any areas with a value less than this will automatically be recorded as white.

Window

An area of a computer display which shows the contents of a folder, disc or document. Several windows can be open at the same time, although only one can be active. They can be moved around the screen, and may have their size changed.

Windows™

The name given to Microsoft's™ **Graphical User Interface (GUI)** which sits on top of **DOS**, and allows easier operation of the computer. Windows 3.1™ has generally been replaced by Windows 95™. (Other versions include

161

Windows for Workgroups™, and Windows NT™.)

Windows 95™
A new **operating system** for IBM compatible computers, replacing DOS and Windows 3.1™ software.

Wire frame
A technique used in computer graphics whereby complex shapes are drawn as a series of polygons in the form of a wire-frame, which can later be **rendered** with a surface texture.

World Wide Web
See **WWW**

WORM (write once, read many times)
An **optical disc** that can only be recorded once with data. This cannot be erased or modified.

Wraparound
1 In word processing, when the end of a line is reached, the computer automatically puts characters onto the next line.
2 In some image processing programs, a value above 255, or below 0 automatically wraps round the next higher or lower value, so a value after 255 becomes 0, and a value below 0 becomes 255.

Write
To record data onto a disc.

Write protected
Where a floppy disc, or removable hard disc is protected against accidental erasure of data. Usually achieved by

sliding a small plastic tag across a hole in the outer casing of the disc.

WWW (World Wide Web) (or often 'The Web')
A part of the **Internet** consisting of many thousands of pages/documents written in **HTML** which enables attractive page layouts, graphics, digital images, and multimedia, plus **hypertext** links to other pages and sites. To view the sites and pages, **browser** software such as Netscape™ and Microsoft Explorer™ are required. There are extensive search facilities within the Web by means of 'search engines' such as Lycos™, Alta Vista™ and Yahoo™.

WYSIWYG (what you see is what you get)
Refers to the relationship between the screen display and final output.

163

Xx

xRes™

An image processing program which uses a **proxy** formula to represent large images in xRes native format. Any changes made to these files must be applied to the final output file.

Yy

y

The term used to describe the **luminance** part of the **YCC** format.

YCC

A colour model which is the basis of Kodak's **PhotoCD** system. The YCC format has one **luminance** (Y) and two colour, or **chrominance** channels (CC).

Yellow Book

This **Colour Book standard** specifies two recording modes for storing digital data on **CD ROM**s. Mode 1 is for computer data, mode 2 is for compressed audio and video data.

See also **Colour Book standards**

Young Helmholtz Theory

The hypothesis that there are three different light sensitive receptors (cones) on the retina that are sensitive to red, green and blue light, and that all other spectral colours can be perceived through the relative stimulation of these receptors. First proposed in 1801, the theory is largely accepted, on the basis of physiological evidence.

Zz

Zip™ drive
A form of removable hard disc storage using 3.5 inch
diameter discs of 100 Mb capacity.

Zoom
1 In photography/imaging – a lens of variable focal
 length, e.g., 35–70 mm, 80–200 mm.
2 In image processing – to enlarge (zoom in), or
 reduce (zoom out) the size of the displayed image.

Related titles from
Focal Press...

Electronic Imaging for Photographers 2ed

By Adrian Davies, Senior Lecturer Electronic Imaging, North East Surrey College of Technology and Phil Fennessey, Technical Executive Digital Imaging Division, Kodak

'Whether you're just getting into digital imaging or a relatively old hand, this book will probably be one of the best £19.99 you've ever spent. Highly recommended.'.
Professional Photographer

'A book that delivers what it sets out to do – to introduce photographers to all aspects of electronic imaging technology.'
Journal of Electronic Imaging

'...aimed squarely at cutting through the jargon and explaining how it all works in a way that a computer rookie can under-stand...I can strongly recommend it to anyone with an interest in the subject, whether beginner or accomplished user.'
Electronic Imaging Magazine

Written in an easy to understand manner, the book introduces photographers to all aspects of the new technology, from image capture and manipulation to output and legal and ethical issues. Well established as the leading introductory text on the subject this new edition has now been completely updated and expanded to give even more depth of information on the very latest technology: it is the definitive guide to electronic imaging.

0 240 51441 6 256pp 245mm x 189mm Paperback
January 1997 £19.99

Scanning and Printing

By Anton and Peter Kammermeier, Megasys DTP-Service, Germany

'*Scanning and Printing* taught me much about the mysterious world of scanning and printing and is a valuable companion for the desktop publisher...the book is printed on high quality paper and the publishers have made sure it looks good.'

Personal Computer World Magazine

'Crammed full of critically useful data and advice...an excellent and thorough subject coverage.'

Professional Photography in Australia Magazine

'This book is an informative guide to various aspects of scanning and printing with DTP. It would make useful reading for attendees on any of our hands-on training courses which cover scanning and related areas.'

Training Manager, Epson Training

This book describes the basic principles involved in DTP (Desktop Publishing) and provides practical guidance, hints and tips. A large part of the book is devoted to the subject of correct scanning and printing for all users of DTP technology. In order to obtain optimum results when scanning and printing photographs, it is important to have a basic understanding of the technology.

The contents of this book cover not only the processing of pictures (even those which have been taken by video camera), photosetting and printing, but also the whole spectrum of ergonomics, typography, advertising and the purchase of DTP systems.

0 240 51400 9 350pp 246 x 189mm Paperback 1992 £29.50

ORDER NOW!

**Call our Heinemann Customer Services
department for a direct purchase on
(01865) 314627 – please have your credit
card details ready, or simply e-mail:
bhuk orders@repp.co.uk.**

**For more information on Focal Press titles
call for a catalogue on (01865) 314556**

**FIND US ON THE WEB!
http:/ /www.bh.com / focalpress**

. . . for the very latest information on all our titles